Ancient
Corinth
Site Guide

Ancient Corinth
Site Guide

SEVENTH EDITION

Guy D. R. Sanders,
Jennifer Palinkas, *and*
Ioulia Tzonou-Herbst,
with James Herbst

AMERICAN SCHOOL OF CLASSICAL STUDIES AT ATHENS
PRINCETON, NEW JERSEY

*Publication of this book was made possible
in part through the generosity of
Dawn Smith-Popielski and Dominic Popielski.*

Book design and layout: Mary Jane Gavenda

Library of Congress Cataloging-in-Publication Data
Names: Sanders, Guy D. R. | Palinkas, Jennifer. | Tzonou-Herbst, Ioulia. | Herbst, James. |
 American School of Classical Studies at Athens.
Title: Ancient Corinth : site guide / Guy D. R. Sanders, Jennifer Palinkas, Ioulia Tzonou-Herbst ;
 with James Herbst.
Description: Princeton, New Jersey : American School of Classical Studies at Athens, 2018. |
 Includes bibliographical references and index.
Identifiers: LCCN 2014033311 | ISBN 9780876616611 (alk. paper)
Subjects: LCSH: Corinth (Greece)—Antiquities. | Corinth (Greece)—Guidebooks. | Greece—
 History—To 146 B.C.
Classification: LCC DF261.C65 S26 2018 | DDC 938'.7—dc23

Printed in Italy

Table of Contents

FOREWORD

THE PREVIOUS EDITION OF THE GUIDE to ancient Corinth appeared over 50 years ago. Although the general appearance of the site is much the same, changes in interpretation, especially under the directorship of Charles K. Williams II between 1966 and 1997, require that in the present guide nothing has been retained from earlier editions by Rhys Carpenter (1928, 1933), Charles Morgan (1936), Oscar Broneer (1947, 1951; the last revised by Robert Scranton in 1954), and Henry Robinson (1960). Beginning with texts written as part of a European Union-funded program to digitize the Corinth archive, this guide was compiled with a specific route around the site in mind. It provides information for those making a short visit, for those who have several hours, and for those who want to explore the entirety of ancient Corinth over several days. A separate guide is planned for the Corinth Museum. (The icon Ⓜ in this guide highlights artifacts on display.)

After introductory sections on the history of Corinth and the excavations of the American School of Classical Studies at Athens (ASCSA), the present guide begins with a tour around the fenced area of the site, beginning at the museum, moving on toward the Temple of Apollo ④, then to the South Stoa ⑲, the Forum, and the Lechaion Road ㊱. The next section describes the Odeion ㊻, the Theater ㊼, the Asklepieion �57, and the various other remains of ancient Corinth located both within and without the ancient Greek walls, such as the Sanctuary of Demeter and Kore ㊉ and the Lechaion Basilica ㊻. These monuments are all located on maps in the back of the book and cross-referenced in the text with a numbered icon.

Directions (marked with the icon ⓐ) are provided to guide the visitor from one monument to the next within the Forum. For sites outside of the Forum, directions have also been given; these directions are primarily intended for walkers. Walking in Greece is enjoyable and is certainly the best way to understand the landscape, both modern and ancient. Total trip distance and time are given from the entrance to the archaeological site unless the starting point is the exit from the site, in which case the estimates begin there. Trip times are based on walking speeds of approximately 12 minutes per km (5 km/hr.) with adjustments for slope. Hints for drivers have been added where appropriate. To estimate the driving time, walking times can be

divided by five. Drivers should note also that some of the directions lead walkers through the village square, or *plateia*, which is usually barred to automobiles. In these cases, circumnavigation of the square has been left up to the driver.

A glossary of technical terms is provided at the back of the guide. Short bibliographic notes (marked 📖) are also provided for many entries to lead the reader to fuller descriptions of monuments, objects, and concepts. A bibliography at the end lists the principal publications of the American School of Classical Studies at Athens that deal with ancient Corinth. More information about the site can be found at www.ascsa.edu.gr/index.php/excavationcorinth, and excavation photographs, notebooks, and drawings can be seen at ascsa.net.

Hundreds of scholars, students, and workmen have contributed to the work of the American School at ancient Corinth since 1896. Those who have made the greatest individual contributions to this guide are Lenio Bartzioti and Ino Ioannidou, many of whose photographs are illustrated, and Charles K. Williams II, whose architectural drawings and plans are frequently used. James Herbst orchestrated the artwork program for the guide, and created many of its illustrations.

Guy D. R. Sanders
Director, Corinth Excavations (1997–2017)

HISTORY AND TIMELINE

Prehistory and Protohistory (6500–700 B.C.)	
ca. 6500 B.C.	Earliest Neolithic finds from the area of Corinth
ca. 3250–1050 B.C.	Bronze Age
ca. 1680–1050 B.C.	Late Helladic period Corinthian elite buried in tholos tomb
ca. 1050–700 B.C.	Iron Age
ca. 750–657 B.C.	Rule of the Bacchiads Corinthian colonists founded Kerkyra (Corfu) and Syracuse
Archaic Period (700–480 B.C.)	
ca. 657–627 B.C.	Rule of the tyrant Kypselos
ca. 627–587 B.C.	Rule of Periander, son of Kypselos Commercial and industrial development Corinthian pottery widespread around the Mediterranean
ca. 530 B.C.	Temple of Apollo (currently visible phase) built
490–479 B.C.	Persian Wars
Classical Period (480–323 B.C.)	
431–404 B.C.	Peloponnesian War
395–387 B.C.	Corinthian War
338–243 B.C.	City held by Macedonians
Hellenistic Period (323–146 B.C.)	
243 B.C.	Acrocorinth captured by the Achaian commander Aratos
146 B.C.	Corinth sacked by Mummius
Interim Period (146–44 B.C.)	
Roman Period (44 B.C.–late 3rd century A.D)	
44 B.C.	Corinth refounded by Julius Caesar
A.D. 50–52, 56, 57	St. Paul visits Corinth

A.D. 67	Excavation of Corinth canal begins
2nd century A.D.	Many public buildings built by patrons including Herodes Atticus
Late Antique Period (late 3rd century A.D.–6th century A.D.)	
Late 4th century A.D.	Earthquakes cause damage in Corinth
A.D. 395	City "burned" by the Visigoths under Alaric
Early 5th or mid-6th century A.D.	Construction of the Hexamilion and new city walls
A.D. 521/2	Major earthquake damages Corinth
A.D. 542	Plague kills half the population
Byzantine Period (7th century A.D.–A.D. 1210)	
ca. A.D. 800–1210	Corinth is capital of the province of the Peloponnese
Frankish Period (A.D. 1210–1458)	
A.D. 1210	Geoffrey de Villehardouin captures city
A.D. 1358	Acrocorinth comes into possession of a Florentine prince
A.D. 1395	Acrocorinth falls under Byzantine control
First Ottoman Period (A.D. 1458–1687)	
A.D. 1458	Acrocorinth captured by Ottomans
Venetian Period (A.D. 1687–1715)	
Second Ottoman Period (A.D. 1715–1821)	
Hellenic Republic (A.D. 1821–present)	
A.D. 1858	Village of Ancient Corinth damaged by an earthquake
A.D. 1896	ASCSA begins excavating at Corinth
A.D. 1928 and 1930	Ancient Corinth and New Corinth damaged by earthquakes
A.D. 1931	Corinth Museum built by ASCSA and donated to Greece

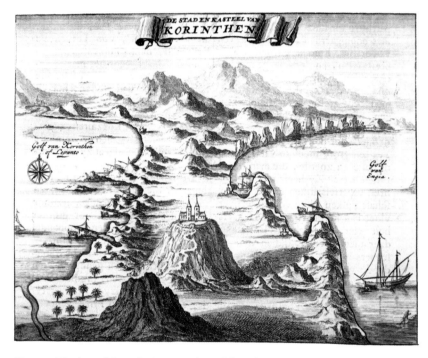

Figure 1. Woodcut of Corinth, Acrocorinth, and the Isthmus in 1688

INTRODUCTION

FROM EARLIEST ANTIQUITY through medieval times Corinth has been a commercial hub acting as both as an *entrepôt* and an emporium, moving cargos from one location to another while also serving as a distributor for its own region. The great wealth of Corinth was not always on display in the form of flashy monuments; it was invested in commercial ventures. Nevertheless the city's monuments were built on a truly impressive scale. In the Late Archaic period Corinth erected the iconic Temple of Apollo ❹ that overlooks the site today. In the Early Classical period the Corinthians erected an even larger temple, approaching the Temple of Zeus at Olympia in scale, of which a few blocks survive in the area of the Gymnasium ❺❻. When it was built in the Early Hellenistic period, the South Stoa ❿ was the largest public building in Greece. Roman Corinth possessed a beautiful fountain house, Peirene ❸❼, three basilicas, and Temple E ❶ set within a huge colonnaded *peribolos*. The Christian basilica at Lechaion ❻❽ is one of the largest buildings of its kind.

The key to understanding Corinth and its wealth is its location. Corinth stands on the Isthmus, a narrow neck of land 6 km across, which connects the Peloponnese to mainland Greece. All land traffic passing from Thebes, Athens, and beyond to Olympia, Sparta, and Argos had to pass Corinth and its imposing acropolis on Acrocorinth (Fig. 1). Corinth was the center of the network of road communications in southern Greece. In antiquity, the circumnavigation of the Peloponnese was dangerous and time-consuming. The Corinthians recognized the advantage of portaging cargos over the Isthmus and in the Archaic or Early Classical period built a paved roadway, the Diolkos, from the port of Schoinous on the Saronic Gulf to Poseidonia, the port on the Corinthian Gulf (Fig. 2). This roadway had the potential to carry carts and even small ships with their cargos. In addition, and quite separate from this transshipment operation, Corinth had two major harbors: one at Lechaion north of the city and the other at Kenchreai on the east coast. These were such an integral part of Corinth that coins of Septimius Severus minted at Corinth showed Acrocorinth and the Fountain of Peirene between personifications of the two harbors.

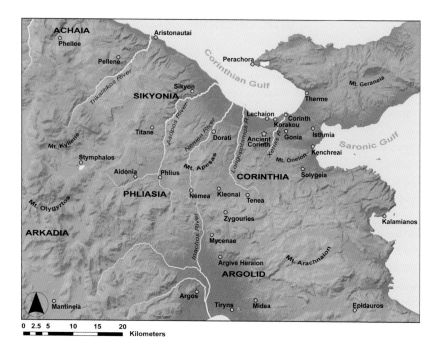

Figure 2. Map of the Corinthia and adjoining regions

Just as Corinth's prosperity in times of peace lay in its advantageous location, in times of war its strategic position was the source of its misfortunes. This is attested by several attempts from antiquity to early modern times to close the land routes with walls, most notably the Late Antique wall stretching 8 km from modern Corinth to beyond Isthmia. In many respects, this fortification wall, built to protect the Peloponnese, may be considered a form of trophy. Built perhaps by the emperor Justinian (A.D. 527–565), its inner and outer faces contain blocks taken from the temples and civic buildings of Corinth, the sanctuary of Poseidon at Isthmia, and the sanctuary of Hera at Perachora. Its lime-mortar core was created by reducing the marble sculptures, architectural pieces, and inscriptions of these same Corinthian sites. Effectively it is a *damnatio memoriae,* or condemnation of memory, of the ancient world in which Hellenic gods were worshipped, before being replaced by a Christian world ruled from Constantinople.

In the wars of succession after the death of Alexander the Great, the Isthmus was a scene of almost constant warfare. In 146 B.C., the

Roman general Lucius Mummius defeated the army of the Achaian League on the Isthmus and reduced the city of Corinth to a mere village. It remained thus until refounded as a colony by Julius Caesar in 44 B.C. Corinth was also the place to hold and defend in the Byzantine, Frankish, Ottoman, and Venetian periods, and it played a key role in the Greek War of Independence. It was once seriously considered as the site of the Greek republic's capital.

Corinth is a large city encompassed in the Classical period by ca. 10 km of fortification walls. Archaeological excavations have taken place mainly in and around the Roman Forum but also as far away as Acrocorinth ➎⓿ in the south, Lechaion ➏⓼ on the northern coast, near the Kenchrean Gate to the east (near ➏➌), and the Potters' Quarter ➎➋ in the west. The city's archaeological record, a small part of which is on view in the museum, spans all periods from the Neolithic down to the present. Books and articles written about Corinth are as relevant to scholars working in Italy as they are to those working in Turkey. Arguably, the archaeological and published records make Corinth the most important of all Byzantine sites. Similarly, Corinth's early prowess in stone architecture, from at least 900 B.C., and the products of its Archaic potters, which spread throughout the Mediterranean littoral, make Corinth one of the most important Geometric and Archaic sites in Greece. Finally, Corinth is of paramount importance to Pauline scholars and to devout Christian pilgrims.

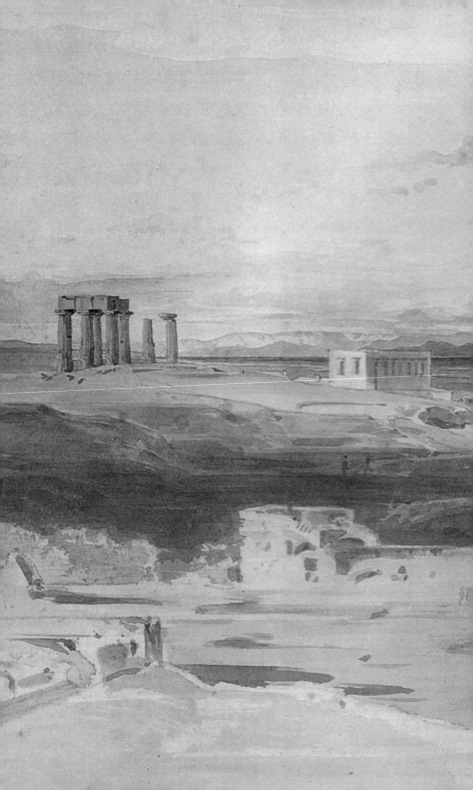

History
of
Corinth

THE AREA OF THE SITE EXCAVATED TO DATE consists largely of the Roman Forum and its surroundings. This zone is the transition (marked by a steep 15 m, 10–20 degree slope) between the two geological terraces on which ancient Corinth was built (see p. 48). In this area, the natural drainage pattern has created a fairly broad valley, allowing relatively easy movement of wheeled and pedestrian traffic between the terraces. The upper valley is occupied by the Forum, and the lower valley by the Lechaion Road.

PREHISTORIC TO GEOMETRIC PERIODS
(6500–700 B.C.; PLAN 1)

There is ample evidence for prehistoric settlement dating from the Neolithic to Submycenaean periods (6500–1050/1025 B.C.), such as wells, deposits, and some structural remains (see pp. 176–178). The earliest Geometric period is represented by domestic debris in the valley floor, graves, and a well. Then, in the 8th century B.C., Corinth is believed to have undergone synoecism, when a group of smaller settlements coalesced into a larger one, while the inhabitants also sent out trading colonies to Syracuse and Corfu. The second half of the 8th century B.C. saw some changes including traces of architecture in the area south of the Sacred Spring ③③, the formalizing of Peirene ③⑦, and a drain and lack of burials in the area later occupied by the Forum.

ARCHAIC PERIOD
(700–480 B.C.; PLANS 2, 3)

In the 7th century B.C. the first temple ④ was built on Temple Hill, the rise to the north of the Forum. To the north of the temple was a roughly contemporary road ⑦. The Sacred Spring ③③ was elaborated, and cult practice perhaps began to be associated with the monument. In the mid-7th century B.C. small buildings, perhaps houses or workshops, including one with a well, were constructed to the south of the spring.

During the 6th century B.C., in the Lechaion Road valley, the Cyclopean Fountain ③⑧ was constructed and buildings were raised facing the road toward Acrocorinth. On Temple Hill, the Early Archaic temple was destroyed ca. 580 B.C., and was replaced about

50 years later by the temple ❹ that still stands on the site. The formal approach was from the northeast, but access was supplemented by a monumental ramp up from a street that ran past the Sacred Spring ㉝ to the southeast. To the east of the temple at the base of the cliff separating it from the valley a small stoa was built, known as the North Building ㊹. A cluster of Protogeometric graves was bounded by a *temenos* wall creating the Heroon of the Crossroads ㉖, and a small underground shrine was established alongside a new road to Acrocorinth ㉚. Outside the area of the Forum the earliest architectural remains of the important sanctuaries of Demeter and Kore ㊾ and Asklepios ㊼ date to the 6th century B.C.

CLASSICAL AND HELLENISTIC PERIODS
(480–146 B.C.; PLANS 3–5)

The 5th to the mid-4th century B.C. saw rapid, organized, and formalized development that gives the impression of a thoroughly urban space. Draw basins were added to the Fountain of Peirene ㊲ and Temple A ㊶ was constructed to its north, while the Sacred Spring ㉝ was further developed with a triglyph-and-metope wall connected by a tunnel to a curious apsidal structure. A racecourse ㉓ more or less followed the line of a road leading southwest from Peirene ㊲, and the buildings that flanked it were replaced by larger complexes. To the southwest the Punic Amphora Building ⑱, the house of a merchant dealing in imported fish fillets, was constructed. Later in the Classical period, the Theater ㊼ and Buildings I–IV ㉛ were built.

The location of Corinth's Greek *agora* is still unknown. It may have been situated northeast of Temple Hill, in roughly the area of the modern village *plateia*. Some have suggested that it occupied the site of the later Roman Forum, but during the Greek period this valley had a relatively steep and continuous slope from the Sacred Spring toward the south, which required terracing and leveling to build the racecourse. The area was dedicated to cults of a very local nature and seems to have been devoted to the education of Corinthian youth.

At the end of the 4th century B.C. the whole area was completely redesigned, probably under the instructions of the Macedonian king Demetrios Poliorketes. The erection of a huge stoa, the South Stoa ⑲, resulted in the demolition and burial of Buildings I–IV ㉛,

the displacement of the Stele Shrine ⓲, and the realignment of the racecourse ㉓. The racecourse covered the southern end of the Sacred Spring complex �33 and the Northwest Stoa ⓭ was built flanking the road running past the Sacred Spring's apsidal building. The Stoa blocked the access ramp from the road up to the Temple of Apollo ❹. A new stoa closed the east side of the Fountain of Peirene �37, creating a more formalized court. Temple A was demolished and replaced by an *aedicula* (small shrine) ㊶.

ROMAN AND LATE ANTIQUE PERIODS
(44 B.C.–6TH CENTURY A.D.; PLAN 6)

In 146 B.C., after defeating the Achaian League led by the Corinthians at Leukopetra on the Isthmus, the Roman general Lucius Mummius sacked Corinth. Of those inhabitants who did not flee, the women and children were sold into slavery, and the men were killed. Corinth continued to be occupied, but had lost its status as a political entity. Corinth was refounded in 44 B.C. by Julius Caesar as a Roman colony.

In the Early Roman period the Forum was a huge open space measuring ca. 200 m east–west and 100 m north–south, taking its orientation from the surviving South Stoa ⓳, which defined its southern edge. The Archaic Temple of Apollo ❹ on Temple Hill dominated the skyline to the north. To the east and west, the Forum was defined by the Julian Basilica ㉔ and Temple E ❶, respectively.

One hundred years later the form of the Forum remained much the same but with additions such as the temples at the west end of the Forum ⓯, shops to the east and west of the Bema ㉘, and a new basilica south of the South Stoa ⓴.

In the Late Roman period Corinth seems to have been radically transformed. Earthquakes in the late 4th century A.D. and the incursions of Goths reduced the city. The sanctuaries of Demeter and Kore ㊾ and Asklepios ㊿, already under legislative pressure to close, did not survive. Efforts were made to refurbish the area of the Forum, however, most notably by reappointing Peirene �37 and the West Shops ⓱ and by converting the Central Shops ㉘ into a broad stairway. In the mid-6th century A.D. the city fell victim first to bubonic plague, with high mortality levels, and subsequently to a deep economic recession that lasted, according to the archaeological

finds, for 500 years. The population relocated in a newly walled, much smaller city east of the Roman Forum (Map 2).

MEDIEVAL TO MODERN PERIODS
(7TH CENTURY A.D.–PRESENT; PLAN 7)

In the Middle Byzantine period, the Corinthian economy and population both began to expand. Corinth had two marketplaces, one in the Frankish Area ❷ and the other in the central part of the Forum, with narrow streets, alleys, shops, workplaces (including a glass manufacturing center), the Church of St. John ⓰, and the Bema church ㉗, which seems to have been monastic. South of the South Stoa ⓳, new excavations have revealed a courtyard house, which at times in its history may have also been a restaurant and a shop, given the large number of unused local cooking pots and imported kettles found there.

Although taken by the Franks after the fall of Constantinople (A.D. 1204), Corinth continued to be an active commercial city in the 13th century A.D., but it declined and was almost depopulated during the course of the 14th century A.D. Descriptions and illustrations of Corinth in the period of Ottoman rule portray it as a small town with houses within walled gardens (Figs. 3, 4). The settlement was destroyed during the Greek War of Independence (1821–1832) and, after an earthquake in 1858, much of the population resettled at New Corinth.

After the earthquake the town of Ancient Corinth was settled by immigrants from the villages of Limnes, Ayion Ori, Angelokastro, and Sofiko, located on stony plateaus in the mountains east of Mycenae. Today it is an expanded version of the town under Ottoman rule, divided into districts that retain their original toponyms: e.g., Kuchuk *mahalla* (*mahalla* is Arabic for an urban subdivision), Tou *bey,* and Hadji Mustafa.

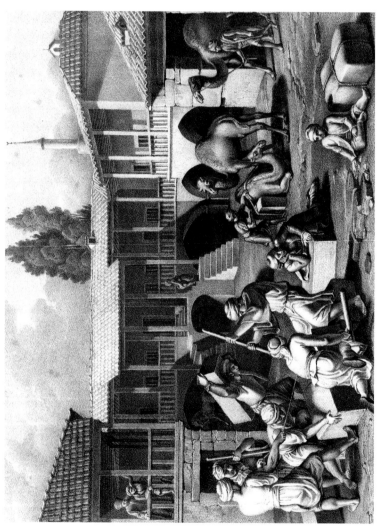

Figure 3. An inn in ancient Corinth in 1811

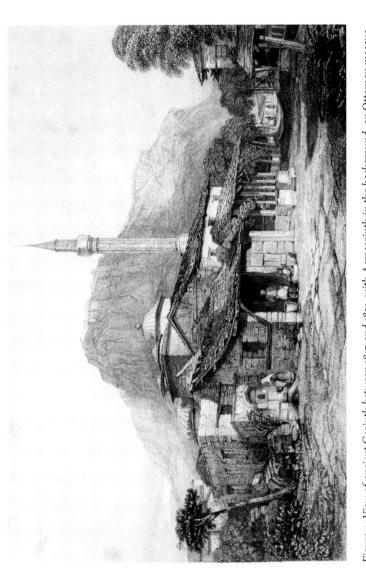

Figure 4. View of ancient Corinth between 1817 and 1821, with Acrocorinth in the background, an Ottoman mosque in the middle ground (on the site of the present Panayia church), and a small square with a public fountain in the foreground

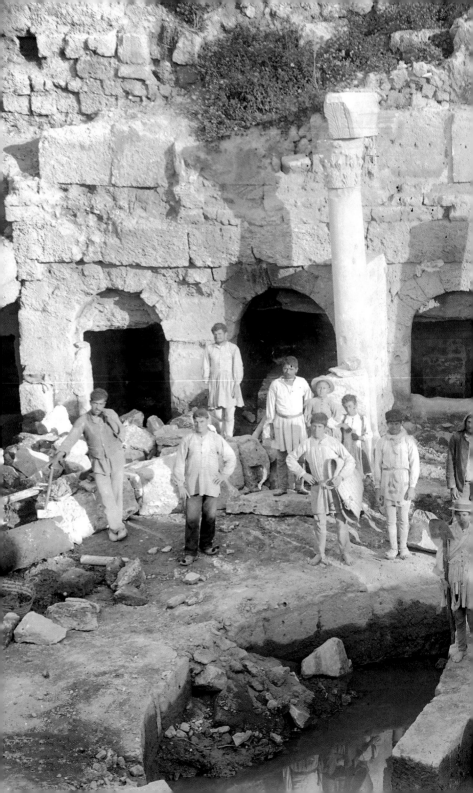

History of the Excavations

THE AMERICAN SCHOOL OF CLASSICAL STUDIES AT ATHENS (ASCSA) has been excavating at Corinth since 1896 (Fig. 5). The earliest excavators were largely concerned with ancient topography and worked quickly to reveal as much of the center of the city as they could. The years between about 1925 and 1940 saw continued but rather more systematic clearance of the Theater **47** and Forum area. Interest shifted from topographic to typological and chronological concerns. At the time, however, it was still generally the practice to excavate with large teams of nonspecialist laborers under limited supervision (Fig. 6). The laborers dug from topsoil to the level of the ancient Forum, a depth of 3 to 4 m in a season (Fig. 7). Although the recovery of data was far superior to the earlier campaigns, it was not what one would now demand. The excavators generated a large volume of literature in the form of books (the *Corinth* series published by the ASCSA) and articles on urban history, buildings, inscriptions, sculpture, ceramics, and minor objects (usually published in *Hesperia,* the journal of the ASCSA). The scholarly literature of this generation shaped present popular conceptions about Corinth and set many of the standards on which archaeologists in the eastern Mediterranean still rely.

Figure 5. The Temple of Apollo in 1902, before its excavation, from the south

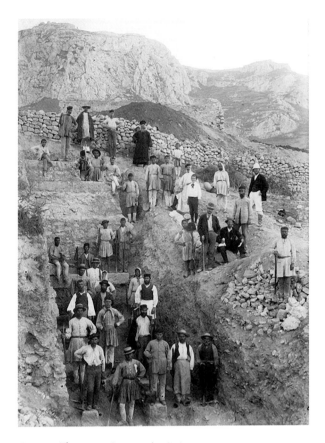

Figure 6. The excavation crew in 1896

Beginning with the directorship of Charles K. Williams II in the mid-1960s, the approach of archaeologists to Corinth has undergone a sustained period of ideological and methodological evolution, if not revolution. During this period of exciting intellectual transformation, the focus has shifted to study the "human" rather than the "monumental" aspects of the ancient world. The volume of work undertaken in the last 35 years has not radically changed the overall plan of the site but has led to a significant transformation of our understanding of the urban and historical landscape. Systematic excavation by small teams of trained technicians supervised by an archaeologist recorder replaced the earlier methodology. Corinth is now excavated using a western European single-context, open-area system. Williams

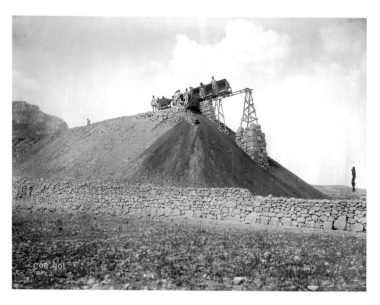

Figure 7. During the early excavations of Corinth, the large amounts of fill removed from the Forum were used to create a sizeable excavation dump to the north of the site.

introduced new procedures for the recording of portable finds, and these provided the framework for Corinth's new relational database.

The study of Corinthian topography considers the Corinthia as a whole. Following on from a topographic overview of the Corinthia published in 1932 (*Corinth* I), James Wiseman's extensive survey of the region (*The Land of the Ancient Corinthians,* 1978) put many sites on the map. Others have continued to add new *topoi* to this basic work; three recent doctoral theses have examined the borders of Corinth with Epidauros, Sikyon, and Argos. The Nemea Valley Archaeological Project (NVAP) and the Eastern Korinthia Archaeological Survey (EKAS) were intensive surface surveys of blocks of the Corinthian landscape. These added a new dimension to our understanding of the region's historical geography.

Mary Walbank was the first to discuss Roman land division in the Corinthia. David Romano and Panos Doukellis have since extrapolated, independently, different schemes of mensuration—the measurement of areas and lengths—on the basis of crop marks, field boundaries, and roads. Resistivity survey—a preexcavation method

for determining the size and shape of an archaeological site—in recent years has added much of topographical interest to the picture presented by the excavated remains.

The American School has also been active in excavation outside the city but within its territory. Elizabeth Gebhard and her colleagues have continued the excavations and publication program started by Oscar Broneer at the major Corinthian sanctuary at Isthmia, dedicated to the god Poseidon and hero Palaimon. Timothy Gregory and his colleagues have continued Paul Clement's work in the Late Roman fortress and Roman baths, also at Isthmia. Robert Scranton excavated above and below the water line at Kenchreai. Work in the area is now being continued by Joseph Rife. In addition to American investigations, the British School at Athens excavated and published the sanctuary of Hera at Perachora under Humfry Payne and later Richard Tomlinson.

At the time of this guide's publication, archaeological activity at Corinth is at an all-time peak. The construction of a new railway and the widening of the road between Corinth and Patras have resulted in the discovery of an extensive cemetery dating from the Middle Bronze Age to the Proto-Byzantine period. It has also revealed stretches of the Archaic city wall and an extensive section of Mycenaean Corinth. Conservation of the Christian basilicas at Lechaion and at Kraneion is preparing these attractions for visitors. In the central fenced area excavation continues in Proto-Byzantine and medieval levels to the south of the South Stoa. The Frankish Area south of the museum is under conservation and will soon be open to the public while studies for the conservation of the South Stoa and the Fountain of Peirene are now complete. The newly refurbished east and south wings of the museum opened to the public in 2016 and show the wealth of the city and its territory from the time of the colonies through the time before the Romans.

Site Tour:
Forum

THIS TOUR CONDUCTS THE VISITOR on an excursion around the monuments within the fenced area of the site (see Map 1 in back of book). It begins with Temple E, the large temple just outside the museum ❶ and continues with the medieval structures to the south ❷. From here the reader will be led back toward the site entrance, past the Fountain of Glauke ❸ and on to the Temple of Apollo ❹. Following the temple, the route around the Roman Forum follows a counterclockwise path past the West Shops ⓱, through the South Stoa ⓳ to the Sacred Spring ㉝, on to the Fountain of Peirene ㊲, and down the Lechaion Road ㊱. Just outside the fenced area the visitor will find the Odeion ㊻ and the Theater ㊼.

After touring the monuments inside the fence, the more energetic will be guided to monuments outside the Forum (see Map 2 in back of book), such as the Asklepieion ㊼ and the Kraneion Basilica ㊿. Finally, the huge Lechaion Basilica ⓰, one of the largest churches in the Late Roman world, and the Bronze Age site of Korakou ⓰ are accessible by car or by public bus (which departs from the stop 100 m west of the site entrance).

❶ TEMPLE E

N Exit the museum from the south entrance and look to the west.

Standing 9 m above the Forum, Temple E occupied as prominent a place in the Roman city as the Temple of Apollo ❹. Today the museum obstructs the connection between Temple E and the Forum, and diminishes the visual impact it would have had from the city center. The museum also interrupts the connection between Temple E and the West Shops ⓱.

In its first phase, the temple had stone foundations, probably with a triple krepidoma measuring 44 × 23.5 m, on which was constructed a limestone Doric temple with six columns across its facade (Fig. 8). The temple enclosure was bounded by a wall to the west and by stoas to the north and south (Fig. 9). It dates to the early 1st century A.D., soon after the death of Augustus.

In the late 1st century A.D. the temple was radically altered. The new building was constructed of marble in the Corinthian order on a podium 3.4 m high and was surrounded by a colonnade of six columns across the short sides and 12 along the long sides (Figs. 9, 10). The temple had a *pronaos* (porch) with two columns *in antis* and

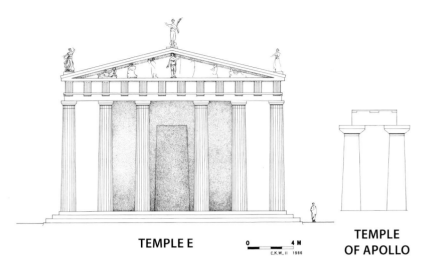

TEMPLE E

TEMPLE OF APOLLO

0 ___ 4 M
C.K.W., II 1986

Figure 8. Elevation of Temple E in its original form, in the Doric order

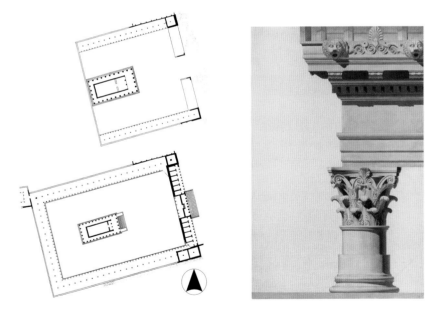

Figure 9 (left). Plans of Temple E during its original Doric phase (above), and its later Corinthian phase (below)

Figure 10 (right). Elevation of Temple E after its rebuilding in the late 1st century A.D., in the Corinthian order

a long, narrow *cella*; a stairway gave access to the *cella* on the east side. The temple was completely enclosed by colonnaded stoas during this phase. On the east side, the stoa had two stories: the upper story faced into the enclosure, but the lower story, now called the West Shops Ⓐ, faced into the Forum.

Visible today are the foundations of the temple's podium, with a truncated restoration of three columns from the facade's colonnade supporting a section of the architrave above. The original height of the columns was much greater. The architrave preserves the cuttings for a dedicatory inscription, which was made of bronze letters and set into these cuttings. Sculptures from the east pediment of Temple E in this phase include depictions of Roma and Apollo Kitharoidos Ⓜ. From the description of the 2nd-century A.D. writer Pausanias (2.3.1), this temple appears to have been dedicated to Octavia, the sister of Augustus, although modern scholars have offered alternative suggestions: the temple might have been a Capitolium, a temple dedicated to the Roman triad of Jupiter, Juno, and Minerva, or it might have been the seat of the worship of the emperor.

Corinth I.2 (1941), pp. 166–236; C. K. Williams II, *Hesperia* 53 (1984), pp. 101–104; C. K. Williams II and O. Zervos, *Hesperia* 59 (1990), pp. 325–369, pls. 57–68.

❷ FRANKISH AREA

🅝 Continue south past the remains of Temple E to the Frankish Area.

The Frankish Area is currently closed, but preparations are underway for it to be open to the public. At that time, the entrance to the area will be along a path between Units 1 and 2, terminating at the northeast corner of room 1 of Unit 1 (Fig. 11). To the right at this point will be the plaza in front of Units 1 and 5, and to the left will be the church of Unit 2.

The central focus of the Frankish Area consists of a large open plaza with a colonnade of reused Roman columns in front of Units 1 and 5 (Fig. 12). It is similar in scale to what had once been considered the marketplace of the medieval city (labeled "Market Avenue" in Fig. 11), further to the east. The large size of the Frankish Area suggests that the assumption that "Market Avenue" was the medieval successor to the Roman Forum is perhaps an error. Instead of a medieval city laid out in the western European style with a single central marketplace,

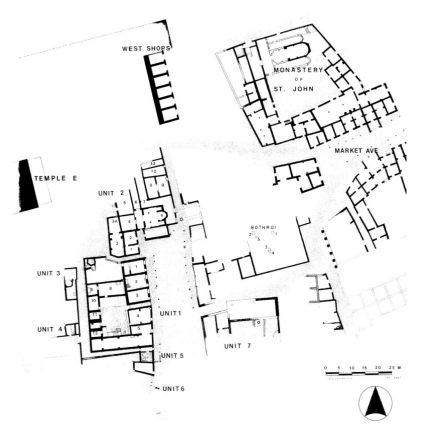

Figure 11. Restored plan of the Frankish Area, southeast of Temple E, ca. A.D. 1300

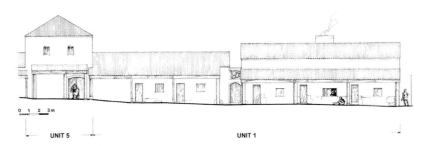

Figure 12. Restored elevation of Unit 1 of the Frankish Area

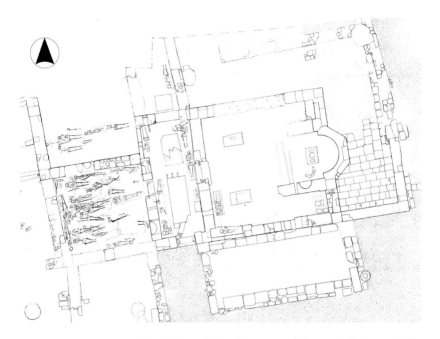

Figure 13. State plan of the small church in Unit 2 of the Frankish Area, with the graves of a later phase west of its narthex

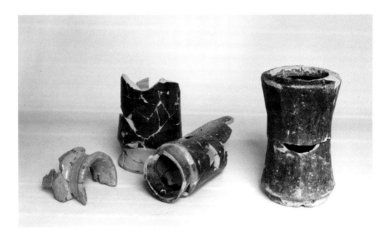

Figure 14. Medicine jars (albarelli) from the Frankish Area. Two are local green-glazed, while the other two, one of blue frit and the other with a dark-green glaze, are imported.

Corinth followed a more Mediterranean plan with multiple *plateiai,* each acting as a focus of ecclesiastical and economic activity. If this is the case, then the excavated area is not the center of the medieval city but probably a part of the periphery.

To the north of the plaza in Unit 2 is a simple, small church with a cloister on its north side, which may have had a monastic function. In a later phase it was also used as a cemetery church with the large majority of the interments located in a small room to the west of the narthex (Fig. 13). The burials show a wide range of fascinating, often lethal pathologies, such as evidence for trepanning (a medical procedure including a hole drilled into the head), bone cancers, death caused by complications during childbirth, and several individuals who suffered from brucellosis (*melitaios*), a bacterial infection caused by the consumption of tainted meat or milk. Finds of medicine jars (*albarelli*) suggest that the monastery may well have had responsibilities for the care and treatment of the sick, old, and infirm, as well as women in labor (Fig. 14).

To the west of the plaza is a complex (Unit 1) with a large central court approached from the plaza by a narrow alley.

C. K. Williams II et al., *Hesperia* 67 (1998), pp. 223–281; C. K. Williams II in *Corinth* XX (2003), pp. 423–434.

❸ FOUNTAIN OF GLAUKE

🡒 Proceed around the west side of the museum, passing Temple E ❶ to the left and return all the way to the ticket booth. Turn right onto the modern path opposite the ticket booth near the entrance to the site.

The Fountain of Glauke, a large cubic mass of limestone, was formed when the surrounding bedrock was quarried away (Fig. 15). Originally, the fountain was contained within a long ridge running west from Temple Hill. Pausanias (2.3.6), who described his visit to Corinth in ca. A.D. 150, reports that the fountain received its name from Glauke, daughter of Creon, the king of Corinth, and the second wife of the hero Jason. Medea, Jason's first wife, in a fit of jealousy because Jason had abandoned her for the younger princess, presented Glauke with a cloak infused with poison. After putting on the cloak, Glauke threw herself into the fountain in an unsuccessful attempt to stop the poison from burning her.

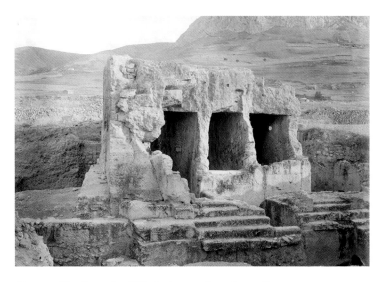

Figure 15. The Fountain of Glauke in 1905, from the north

Similar to the Fountain of Peirene 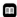, the Fountain of Glauke consists of four large reservoirs fronted by three draw basins and an architectural facade (Figs. 16, 17). Although this facade is now largely gone, still visible are the cuttings for the parapet that formed the front of the draw basins. The cuttings are just before the draw basins in a single line to each side of the cut at the center. In front of the cuttings are the steps that led up to the facade; note also the steps on the west side.

The deep cut through the center of the steps provided a means of removing the stone while digging the reservoirs and would have been filled in when the fountain became operational. Directly to the north of the fountain, framed by the steps, was a small courtyard paved with tiles in the Roman period.

Unlike most fountains in Corinth, the Fountain of Glauke does not exploit a natural spring but instead is fed by water piped in from a source somewhere to the south. This fact, along with several other considerations, such as a recent analysis of the plaster, suggests that the fountain dates not to the Archaic period, as was originally thought, but to the Hellenistic or Roman period.

Corinth I.6 (1964), pp. 200–228; M. E. Landon in *Corinth* XX (2003), p. 48; C. A. Pfaff in *Corinth* XX (2003), pp. 133–134.

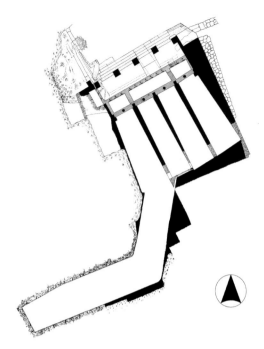

Figure 16. Plan of the Fountain of Glauke

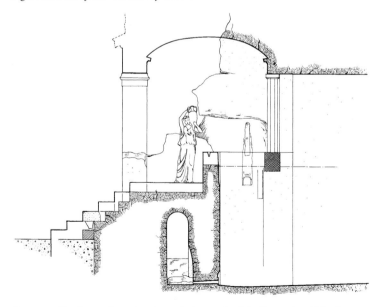

Figure 17. North–south section through the porch of the Fountain of Glauke

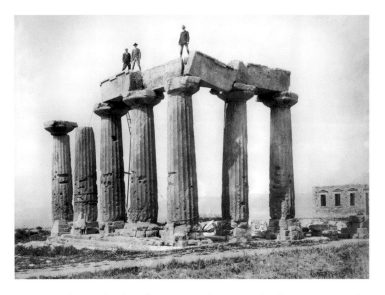

Figure 18. The Temple of Apollo in 1901, with a group of early excavators on the epistyle, from the southwest. In the background to the right is the Capodistrian School.

④ TEMPLE OF APOLLO

⚐ Proceed along the modern path to the Temple of Apollo, crossing the ancient road to Sikyon.

The first temple to stand on this site is known only from very fragmentary architectural remains, none in situ, and archaeological deposits that date its lifespan from the early 7th to the early 6th century B.C. This temple was monumentally constructed of stone, mudbrick, and timber, with a heavy and complex hipped roof of terracotta tiles which sloped on all sides Ⓜ. Also associated are some of the earliest examples of Greek wall painting. Some scholars believe that this temple was a simple structure without exterior columns, while others see similarities with a contemporary temple at Isthmia that had an exterior peristyle.

The seven standing columns of the existing Archaic temple form one of the most prominent landmarks of Corinth (Fig. 18), if not all of Greece. The dedication of the temple to Apollo is deduced from Pausanias's description of Corinth (2.3.6), combined with a small plaque dedicated to Apollo and an inscribed prize *aryballos* (oil flask), both

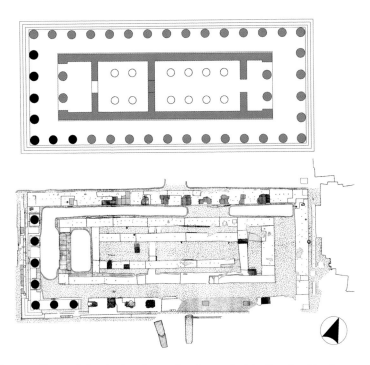

Figure 19. Restored plan (top) and state plan (bottom) of the Temple of Apollo

found in the area Ⓜ. Built in the middle of the 6th century B.C. to replace its destroyed 7th-century predecessor, the temple is of the Doric order and originally had six columns at each end and 15 along each side (Fig. 19). Indications of its Archaic date include the great length of the temple relative to its width, the large monolithic columns, and the squat, widely flaring capitals (Fig. 20).

Although most of the mid-6th-century B.C. building has been destroyed, the bedrock preserves cuttings made to receive the foundation blocks, and thus allows a reconstruction of the temple's plan. The cuttings are visible

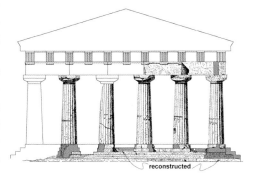

Figure 20. Elevation of the Temple of Apollo

from the east side of the temple. The plan consists of a porch at either end and a long central *cella* divided into two rooms by a crosswall. The traditional reconstruction (shown in Fig. 19) makes this crosswall a solid wall and provides access to the western room of the *cella* through a western door. Alternatively, the crosswall might have been pierced by a doorway, in which case the western room could have served as an *adyton*, or inner shrine. In any case, two rows of columns ran the length of the building within the interior.

From the Archaic period, access to the hilltop was up a monumental staircase at the southeast corner of the hill (Fig. 21). The Roman period, however, introduced many changes to the area. Access to the temple was now from the west, as a result of building activity on the other three sides of the hill, which blocked off the earlier staircase and quarried into the hillsides. The Romans also added colonnades flanking the temple, and carried out a radical renovation of the temple itself. The interior columns were removed and some of them were set up in a row near the west end of the South Stoa **19**, where they are still standing.

Corinth I.1 (1932), pp. 115–134; R. Rhodes in *Corinth* XX (2003), pp. 85–94; C. A. Pfaff in *Corinth* XX (2003), pp. 112–115; N. Bookidis and R. S. Stroud, *Hesperia* 73 (2004), pp. 401–426.

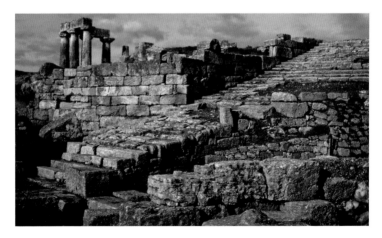

Figure 21. The monumental staircase of the Archaic period that led to the east side of the Temple of Apollo

FROM THE NORTHEAST CORNER OF TEMPLE HILL

Temple Hill is the hill on which the Temple of Apollo ❹ stands. It is a long, sandy limestone ridge that was formed as a submarine dune when the coast of the Corinthian Gulf lapped the base of Acrocorinth to the south. It was exposed by a rapid phase of uplift about 240,000 years ago when the new shoreline was at the base of the cliff to the north of the hill. In antiquity the dune was used as a quarry ⑪.

The view from Temple Hill provides an overview of the topography around the Corinthian Gulf and beyond. To the northeast, Mt. Geraneia is visible, with the town of Loutraki at its base. To the north, in the foreground, is the peninsula of Perachora, site of a sanctuary of Hera. Behind Perachora rises Mt. Helikon, home of the Muses, and to the northwest is Mt. Parnassos, on the slopes of which is Delphi. Farther to the west is Mt. Giona in the region of Phokis.

To the west, Mt. Kyllene, the home of Hermes, is visible. Farther to the south are the mountains of Arkadia. The most prominent topographical landmark to the south is Acrocorinth ㊿, rising above the modern village of Ancient Corinth. The skyline to the east and west of Acrocorinth traces the approximate circuit of the ancient Greek city walls ⑺⓿.

TOPOGRAPHICAL NOTE 1

❺ NORTH MARKET
⓵ Remain at the northwest corner of Temple Hill to see the North Market, the North Stoa, and the 7th-century B.C. road. The North Market and the North Stoa are best seen, however, from the modern road to the north, outside the fenced area.

The southern half of a Roman market square surrounded by a colonnade was excavated on the north side of Temple Hill, while the northern half remains unexcavated under the modern road. Parts of the marble paving of the square and the gutter surrounding it are preserved (Fig. 22). A row of 13 shops opens onto the colonnade on the south side, and remains of other shops were also found along the west and east sides. The colonnade was floored with a mosaic of geometric designs, visible today only during the spring and summer.

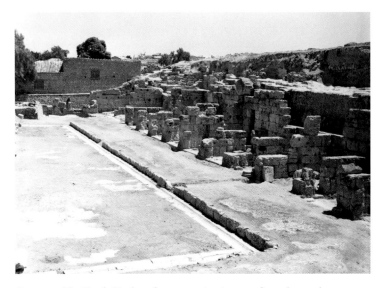

Figure 22. The North Market after excavation in 1949, from the northwest

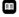

Corinth I.3 (1951), pp. 180–194.

6 NORTH STOA

A stoa north of the temple, partly covered by the later North Market
5 , was two stories high. The first story included an undecorated
cornice above half-columns, while on the second story a Doric
entablature was supported by posts, several of which are displayed
on the foundations. The entablature's painted terracotta sima included
a lion-head waterspout. A coin hoard found in the stoa, containing
41 gold staters of Philip II and 10 of Alexander the Great (Fig. 23),
provides some evidence for a construction date toward the end of the
4th century B.C. Numerous catapult balls found in the stoa indicate
that this building might have served as an Arsenal (Fig. 24). East of
the stoa and also covered by the Roman Market was a structure with
four rooms, perhaps dating as early as the 5th century B.C., which is
known as the Painted Building because of the number of pieces of
painted plaster found.

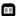

Corinth I.3 (1951), pp. 155–179.

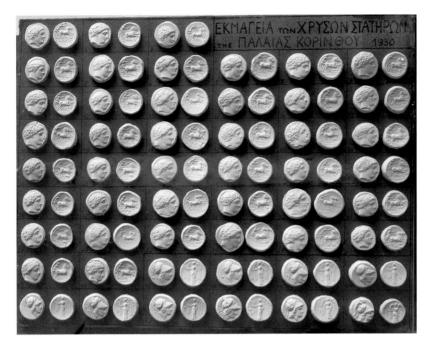

Figure 23. Plaster casts of the coin hoard from the North Stoa (stored in the Numismatic Museum in Athens)

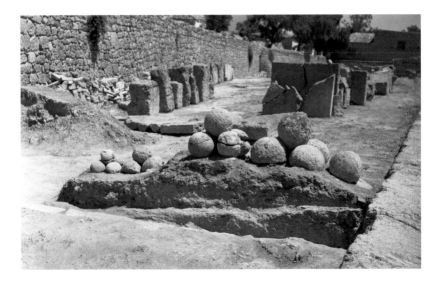

Figure 24. Catapult balls from the North Stoa in 1949

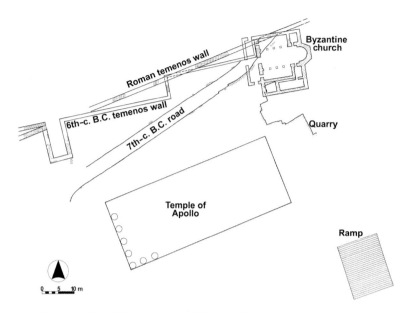

Figure 25. Plan of the north side of Temple Hill

⑦ 7TH-CENTURY B.C. ROAD

A road dating to the 7th century B.C. crossed the area north of the Temple of Apollo ❹, where the bedrock was cut down and leveled to create the roadbed (Fig. 25). Oriented southwest to northeast, the road measured ca. 3 m wide and had been well worn from use, including several deeply cut wheel ruts. A portion of the road can be seen immediately to the north of the roped-off area of Temple Hill, running from the northwest corner of the temple to the Byzantine church ❽.

Corinth I.3 (1951), pp. 155–179; H. S. Robinson, *Hesperia* 45 (1976), pp. 212–217.

❽ BYZANTINE CHURCH

⮚ Walk along the north edge of Temple Hill following the 7th-century B.C. road, to the church.

To the northeast of the Temple of Apollo ❹ are the partially preserved remains of a Byzantine church, dating to the 12th century A.D. The plan of the church included a narthex, a nave, and two aisles (Fig. 26).

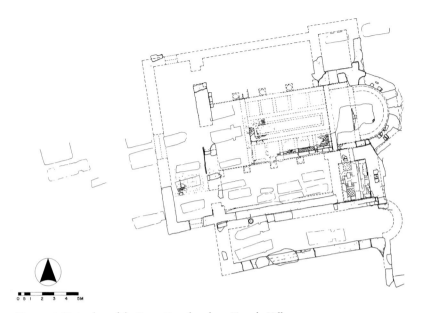

Figure 26. State plan of the Byzantine church on Temple Hill

The aisles were lined with marble columns; two column bases remain in situ, and one complete column is preserved in the nave. A cutting along its length indicates it was part of an altar screen. The preserved foundations include the nave with its apse, a portion of the narthex, and the south aisle. Fragments of marble revetment and a marble *opus sectile* floor, as well as pieces of painted wall plaster, indicate the elaborate decoration of the church.

H. S. Robinson, *Hesperia* 45 (1976), pp. 221–224.

⑨ OTTOMAN HOUSE

🧭 Stay at the northeast corner of Temple Hill to view the remains of the house. Note that the wall and steps are best seen from the modern road.

In the later 18th century, the seven columns then standing on the south side of the Temple of Apollo were incorporated into the wall of a garden. Later, four of the columns were razed to construct a large, luxurious house. The central building, which was three stories high, was built over the eastern two-thirds of the temple; it is depicted in

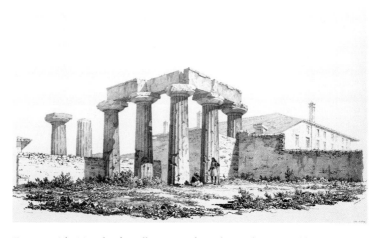

Figure 27. The Temple of Apollo in 1834, from the southwest. Visible in the background are the buildings of the 18th-century Ottoman house.

many drawings by early travelers to Corinth in the 18th and 19th centuries (Fig. 27). Visible today is the retaining wall for the hill in this period, including two sets of steps (Fig. 28), between the Temple of Apollo ❹ and the North Market ❺. The eastern preserved steps are aligned approximately with the east end of the North Stoa ❻, and the western preserved steps are above the fourth shop from west of the North Market.

Corinth I.1 (1932), pp. 127–133; H. S. Robinson, *Hesperia* 45 (1976), pp. 221, 223.

Figure 28. Reconstructed section of the steps dating to the Ottoman period, in the area north of Temple Hill

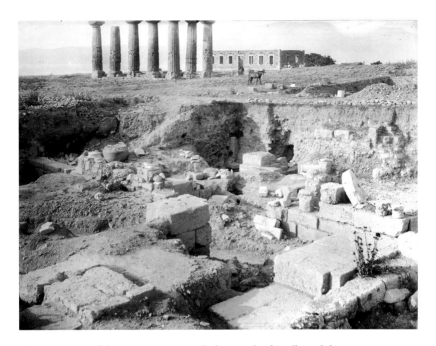

Figure 29. View of the Forum in 1903, with the Temple of Apollo and the Capodistrian School in the background

⑩ CAPODISTRIAN SCHOOL

Sometime after 1829, the northeast corner of the foundations of the Temple of Apollo ❹ was covered by a two-story structure known as the Capodistrian School, named for Ioannes Capodistrias, the first president of Greece. Capodistrias visited Corinth in 1829 and perhaps personally encouraged the construction of the school at that time. In the earthquake of 1858, the building lost its roof, but it remained standing until the early 20th century (Fig. 29). The foundations of the school rise above and to the south of the foundations of the Byzantine church ❽.

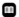

H. S. Robinson, *Hesperia* 45 (1976), pp. 238–239.

GEOLOGY

The local geology of Corinth is dominated by deep marine sediments, marl clay impervious to water, overlain by capping layers of porous sandy or pebbly limestone (Fig. 30). Older Jurassic limestone entities, such as the hill on which Acrocorinth sits, extrude through the later deposits to heights of over 570 m. Uplift of the land relative to the sea has created a series of broad terraces terminating in raised beaches marked by vertical cliff faces. The ancient city is situated on two such terraces at the foot of Acrocorinth, one ca. 90 m and the other ca. 60 m above sea level. Where the interface of the limestone and marl has been exposed by the terraces, there are several natural springs. The Isthmus to the east of Corinth is relatively arid, but the coastal plain to the west is well watered by the seasonal rivers that descend from the Ayios Vasilios and Nemea valleys to the south.

The sandy limestones of the marine terraces extend from Kenchreai to Sikyon and have been extensively quarried for stone. The quarries supplied building stone that was exported to Delphi and Epidauros. Some of the marl clays are a source of building mortar and clay for ceramics. The calcareous marl can be calcined to produce calcium oxide that, with the addition of water, reduces to calcium hydroxide, i.e., white lime cement. Some marl clays were used to make terracotta tiles, pipes, figurines, and pottery. The tectonic fragmentation of the region has ensured the perennial threat of earthquakes. These earthquakes rarely exceed a magnitude of 6.5 and have never exceeded 7.0 on the logarithmic Richter scale. They have occasionally damaged major structures, although not as often as some would believe. The nature of the faults in Greece is such that the damage from earthquakes tends to be limited to a few tens of kilometers from the epicenter. Thus an event such as the earthquake of A.D. 551/2, recorded by the historian Procopius at Chaironeia in central Greece, clearly had little effect on Corinth.

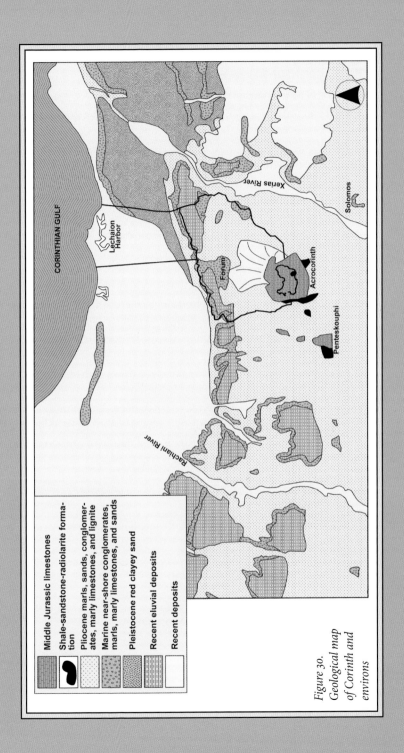

Figure 30.
Geological map
of Corinth and
environs

Middle Jurassic limestones

Shale-sandstone-radiolarite forma-
tion

Pliocene marls, sands, conglomer-
ates, marly limestones, and lignite

Marine near-shore conglomerates,
marls, marly limestones, and sands

Pleistocene red clayey sand

Recent eluvial deposits

Recent deposits

CORINTHIAN GULF

Lechaion Harbor

Forum

Acrocorinth

Penteskouphi

Xerias River

Solomos

Racháni River

⓫ QUARRY

🅝 The quarry is best seen while standing on the foundations of the Capodistrian School.

One would have expected to see the altar of the Temple of Apollo ❹ at the east end of Temple Hill, but it was demolished in the Roman period to quarry the local sandy limestone for building works. The east end of the hill was quarried away, and the large irregular cutting, with an uneven floor cut into rectangular shapes, is part of this work (Fig. 31).

The soft limestone on which the temple stands is easily cut with what are basically woodworkers' tools, e.g., saws and adzes. After it receives its finished surface, the newly cut stone then hardens with exposure to the atmosphere. The technique has been used since the beginning of the Geometric period (ca. 900 B.C.) to make burial sarcophagi; examples are on display in the museum Ⓜ. Similar stone from extensive quarries between Sikyon and Kenchreai supplied blocks for temples and other buildings, including the Temple of Asklepios at Epidauros and the Archaic Temple of Apollo at Delphi.

Stone was extracted by cutting narrow trenches (ca. 10 cm wide) into the quarry floor around the block desired. Wedges were inserted and hammered home to break the bottom surface of the block free of its matrix. The block was then roughly trimmed before transportation to its destination, where it received its final shape. The columns of the Temple of Apollo in Corinth probably came from a quarry on the hill on which it stands. Each is cut from a single piece of limestone 7 m long and weighs approximately 23 tons.

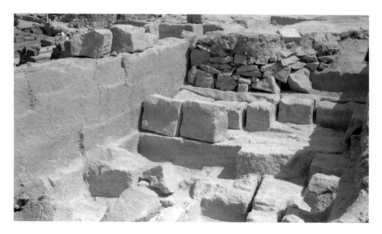

Figure 31. The quarry at the east end of Temple Hill, looking west

TO THE FORUM AND PANAYIA

⚡ Move now from the area between the quarry and the east end of the Temple of Apollo to the southeast corner of Temple Hill.

From the southeast corner of Temple Hill, there is a broad view of the Forum as well as the areas east of the Forum. The Forum, lying at the heart of the Roman city, was the commercial and administrative center of Corinth. Its orientation conforms to the surviving Classical and Hellenistic buildings, such as the South Stoa ⑲, the Southeast Building ㉑, and the Temple of Apollo ❹, which were refurbished for use in the Roman period. The entire area, almost 200 m long and 100 m wide, was paved with slabs made of hard Jurassic limestone. It was divided into upper (south) and lower (north) levels by the Central Shops ㉘ that flanked the Bema (elevated speaker's platform) ㉗. In late antiquity the two levels were united by a broad series of steps that replaced the shops. Three roads led into and out of the Forum: the road to Sikyon, at the northwest corner of the Forum, the road to Lechaion ㊱, at the northeast corner, and the road to Acrocorinth, at the southwest corner ⑱. In the Roman period, the location of each road was marked by a monumental arch.

The buildings around the Forum were largely administrative and religious. They include three large civic basilicas, rows of shops, temples, and offices.

To the southeast of the Forum, along the modern street, the terracotta roof of the elementary school is visible above the site to the southeast of the South Stoa ⑲. Across the street from the school is the Panayia Field ㉒, the site of excavations by the American School of Classical Studies from 1995 to 2007. The field is named for the post-medieval Panayia church that earlier stood in this same location. The church, which was damaged by earthquakes in 1928 and 1930, was demolished in the 1950s. The site of the church is commemorated today by a small shrine located within the village's municipal basketball court. The new Panayia church is prominently located on the hill east of the village square.

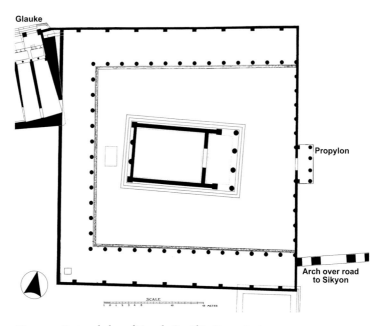

Figure 32. Restored plan of Temple C within its precinct

⑫ TEMPLE C

🡢 Proceed along the south side of the Temple of Apollo, following the modern path down the hill to the southwest. This modern path follows the ancient road to Sikyon. Stop at the point where the modern path turns to the south, directly before the propylon of the *peribolos* of Temple C.

This tetrastyle prostyle Roman temple stands in a precinct surrounded by a colonnade on three sides, and a wall with half-columns on the east, along the road to Sikyon, which leads from the Forum past the Theater ㊼ (Fig. 32). The entire precinct stretched as far west as Glauke ❸. Visible today is the southern end of the propylon, with a fallen column drum within, and most of the southern half of the eastern precinct wall. Near its preserved southeastern edge are the foundations for the western bay of a Roman monumental arch that spanned the road to Sikyon and connected the *peribolos* of Temple C with the Northwest Stoa ⓭. Unfortunately, Pausanias makes no mention of the building, and we have no evidence for the identity of the god or goddess who was worshipped here.

Corinth I.2 (1941), pp. 131–165.

⑬ NORTHWEST STOA

🅝 Opposite the precinct wall of Temple C and across the road at a lower level are the remains of the Northwest Stoa, below the south side of Temple Hill.

The Northwest Stoa was once thought to have been a Hellenistic building refurbished in the Roman period. It is now understood to be a Roman monument built over a smaller Hellenistic stoa. Built in the time of the emperor Augustus (27 B.C.–A.D. 14), the Northwest Stoa closed off the north side of the Forum. It is oriented south of west, parallel with the Roman *peribolos* wall of the Temple of Apollo ❹. The stoa is ca. 101 m long and 9 m wide, with an exterior colonnade of 47 Doric columns and an interior colonnade of 20 Ionic columns (Fig. 33). The bases of several Ionic columns, some with capitals displayed on them, and most of the lowest drums of the Doric columns, are visible today. Local limestone, finished with a fine coat of lime stucco to mimic marble, was used for all the architectural elements. Foundations for a staircase at the west end of the building suggest

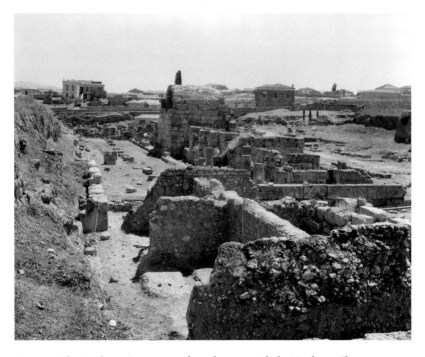

Figure 33. The Northwest Stoa in 1935, from the west, with the Northwest Shops (right) immediately in front of the stoa

that it was a two-story building. When the Northwest Shops were built immediately in front of the stoa it continued to be used, perhaps as a warehouse.

Corinth I.2 (1941), pp. 89–130; C. K. Williams II, *Hesperia* 38 (1969), pp. 52–55, pls. 16–17.

14 NORTHWEST SHOPS

⚡ Move slightly to the south to view the Northwest Shops, adjacent to the Northwest Stoa, passing over the foundations of the monumental arch over the road to Sikyon.

These shops were built immediately in front of the Northwest Stoa 13 later in the 1st century A.D. The large central chamber still preserves its stone vault (Figs. 33, 34), most easily seen from inside the Forum. It is flanked on either side by seven shops, which originally had concrete vaults. On the facade was a colonnade of 28 Corinthian columns.

📖

Corinth I.2 (1941), pp. 89–130.

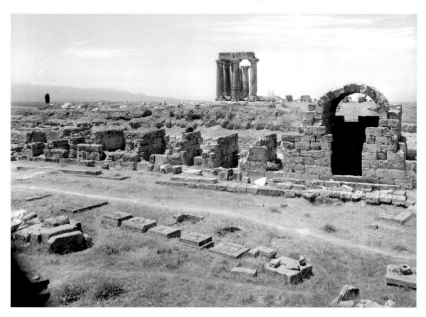

Figure 34. The western end of the Northwest Shops in 1935, from the south. In the background is the Temple of Apollo.

⑮ WEST TERRACE TEMPLES

🔃 Continue to follow the modern path to the south, stopping at the sign to the left. You are now standing between the West Shops ⑰ and the buildings at the west end of the Forum.

The buildings at the west end of the Roman Forum date from the 1st and 2nd centuries A.D. (Fig. 35). In contrast to most temples of both the Greek and Roman periods in Greece, each of the temples here stood on a high podium constructed of rubble and cement. Originally they were clad with marble revetment and most had a staircase on the front side. Each temple was prostyle, with a row of columns at the front. The route followed by Pausanias (2.2.8) at Corinth has been

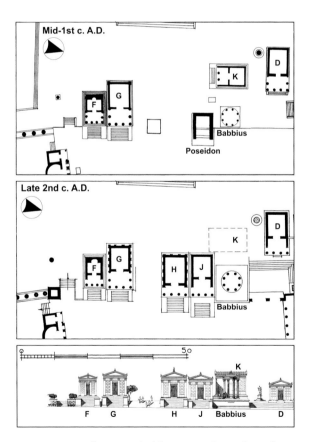

Figure 35. Monuments at the west end of the Forum: plan in the mid-1st century A.D. (top), plan in the late 2nd century A.D. (middle), and elevation (bottom)

disputed, but on the basis of recent archaeological evidence the temples at the western end of the Forum are now identified as follows, from south to north or from left to right as one faces the buildings:

Temple F: Venus Genetrix. Venus in her role as Genetrix was considered the progenitor of the family of Julius Caesar and his descendants, the Julio-Claudians.

Temple G: Apollo of Klaros.

Temple H: Built during the reign of Commodus (A.D. 180–192) and perhaps dedicated to Herakles.

Temple J: Built during the reign of Commodus. Replaced the Fountain of Poseidon, dedicated by Cnaeus Babbius Philinus, and perhaps also dedicated to Poseidon.

Temple K: Temple dismantled in the late 2nd century A.D.

Temple D: Tyche (Fortune).

⚡ Begin with Temples F and G to the south of the wide modern passage to the Forum.

Temples F and G are the earliest in the group. Temple F was Ionic, with four columns across the front, on a three-step krepidoma. The rubble foundations of the temple's podium are visible from the west.

Temple G was perhaps of the Corinthian order. Like Temple F, it had steps leading to it from the Forum. The rubble foundations of Temple G are also visible from the west. The inscription displayed on its foundation (I-1974-2) has been associated with the Long Rectangular Building ⑱ to the south. From the east more of the front of the buildings is visible, and it becomes clear how these podium temples rose above the level of the Forum. The foundations of the steps leading up to each are preserved.

In front of Temple F are additional architectural elements from the building. Several column bases are displayed on the foundations. A corner block from the roof includes a lion-head waterspout and a cutting for an akroterion. A block from the pediment (I-2144) is inscribed with the name of Venus ([VEN]ERI), and a circular mark and its surrounding cuttings held a *clipea ansata,* a sculpted bust inside a circular frame. Also located in front of the temple is part of the semicircular setting for her cult statue.

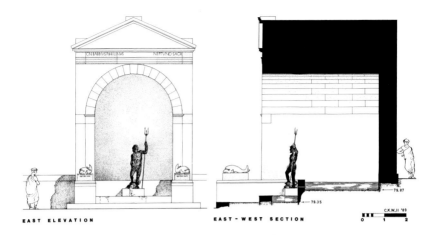

EAST ELEVATION

EAST - WEST SECTION

Figure 36. Elevation and section of the Fountain of Poseidon

🔳 **Move now to the north side of the wide modern path to see Temple H and Temple J, which was built over the Fountain of Poseidon.**

The Fountain of Poseidon is slightly later than Temples F and G, and was built by Cnaeus Babbius Philinus (Fig. 36). A marble dolphin Ⓜ, appropriate for Poseidon, has been associated with this monument. From the Forum, the ashlar foundations of the fountain are visible in front of the foundations of Temple J, which consist of the rubble interior of the podium and the steps on the east side. The inscribed architrave (I-2146) currently displayed on the foundations of the fountain belongs to the temple and includes parts of the name and titles of the emperor Commodus. The majority of the text was erased in antiquity as part of the emperor's *damnatio memoriae,* the condemnation of his memory.

The preserved remains of Temple H include rubble foundations and the ashlar masonry facing the rubble on the west side of the temple. On the foundations of the steps on the east side, several Corinthian capitals and an inscribed entablature are displayed. The inscription (I-2145) includes part of the titles of Commodus, but his name has been erased. The last line of the inscription records that the temple was built according to the terms of the will of Cornelia Baebia, a prominent Corinthian woman. On the ground to the east of the remains of Temple H is an inscribed base naming Babbius (I-438), which belongs to the Fountain of Poseidon. Temple H and Temple J

PAUSANIAS

The 2nd-century A.D. Greek traveler Pausanias described a visit to Corinth in Book 2 of his 10-volume *Description of Greece* (Fig. 37). His chief interest was in the monuments of art and architecture that he saw, so his accounts are of great interest to archaeologists who try to associate their discoveries with the names and descriptions of ancient buildings in his text.

The chief difficulty in applying Pausanias's observations and descriptions to archaeological remains is that a direct connection between his text and excavated monuments cannot always be easily made. Difficulties arise because his routes around a site might be circuitous, abruptly shifting direction, and interrupted by discourses on local or obscure myths, legends, or religious ritual. Yet his text, in part for these same reasons, also preserves information that might otherwise have been entirely lost.

Pausanias's description of Corinth is extremely useful for illuminating local myths and topographical features outside the Forum, yet problematic when it comes to applying the names of the monuments he identifies in the Forum to the excavated buildings visible on the site today. His description of Corinth begins to the east of the Forum, at Kraneion ⓺ (2.2.4); then, without a mention of the route taken, he begins to describe the Forum, where he says several sanctuaries are located (2.2.6). Again without indicating directions, he describes a temple of Fortune, with a sanctuary to all the gods next to it, and a fountain to Poseidon nearby (2.2.8). The series of buildings at the west end of the Forum ⓯ has been associated with Pausanias's description, though not without debate.

Pausanias left the Forum by way of the Propylaia ㉟ and a court of Apollo ㊵ (2.3.2–3). Later, along the Lechaion Road, Pausanias describes a bath built by Eurykles, which has been identified as either the bath ㊷ excavated beyond the Peribolos of Apollo or the large bath along the Lechaion Road farther to the north ㊺ (2.3.5).

Pausanias then describes another road that departs the Forum toward Sikyon to the west (2.3.6), passing the Fountain

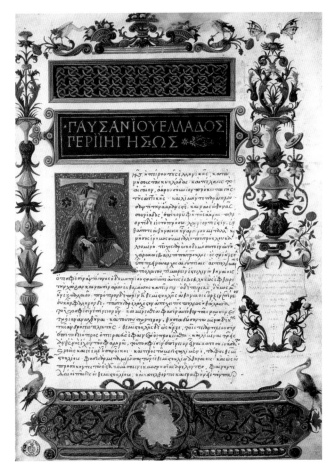

Figure 37. Manuscript of Pausanias's Description of Greece *(1485)*

of Glauke ❸. To the northwest he describes the Theater ㊼, and beyond the Theater a Gymnasium ㊌, a spring called Lerna, and a temple to Asklepios ㊐ (2.4.5).

Ascending Acrocorinth, Pausanias mentions a temple to Demeter and Kore ㊴, and on the summit of Acrocorinth ㊿, a temple of Aphrodite (2.4.7–2.9.1).

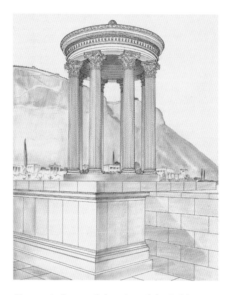

Figure 38. Restored drawing of the Babbius Monument

both date to the reign of Commodus, in the last two decades of the 2nd century A.D. Both were built in the Corinthian order.

The remaining two temples in the area are Temples D and K near the Northwest Shops **14**. Only meager remains of Temple K are preserved, located behind the sign posted along the modern path. Temple D had four columns across the front. The rubble foundations of the podium are preserved, as well as a small section of the pediment, displayed on the south side of the foundations. Both temples likely date to the first half of the 1st century A.D. Prominent to the south of Temple D is the foundation of a circular statue base contemporary with the Babbius Monument.

The Babbius Monument was a circular *monopteros* dating to the early 1st century A.D. (Fig. 38). It consisted of eight Corinthian columns arranged in a circle supporting an entablature and a conical roof. It was erected on a high concrete podium originally clad with marble revetment. The epistyle, displayed today on the foundations, bears an inscription in Latin (I-428):

> *Cnaeus Babbius Philinus,* aedile *and* pontifex, *had this monument erected at his own expense, and he approved it in his official capacity as* duovir. (trans. J. H. Kent)

Babbius Philinus was a rich freedman of Greek descent who served as a local official in the region. He also built the Fountain of Poseidon, which was replaced by Temple J, perhaps also dedicated to Poseidon, during the reign of Commodus. From the Forum, the preserved foundations of the monument provide a sense of the monument's striking height.

General: *Corinth* I.3 (1951), pp. 3–73; C. K. Williams II and O. Zervos, *Hesperia* 59 (1990), pp. 351–356. **Babbius inscriptions**: *Corinth* VIII.2 (1931), no. 132, *Corinth* VIII.3 (1966), no. 155.

⑯ CHURCH OF ST. JOHN

The Church of St. John stood until 1938, when it was demolished to complete the excavation of the Forum down to Roman levels (Fig. 39). Removal of the church revealed the Babbius Monument.

The original church was part of a 13th-century A.D. monastic complex at the west end of a large marketplace overlying the Forum

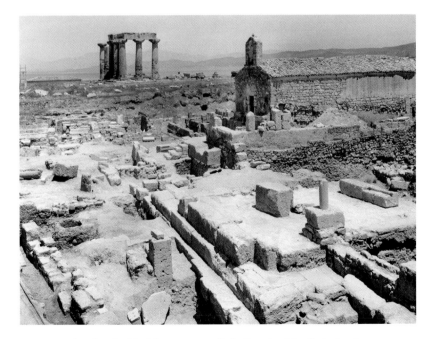

Figure 39. The Church of St. John in 1935, with the Temple of Apollo in the distance, from the southwest

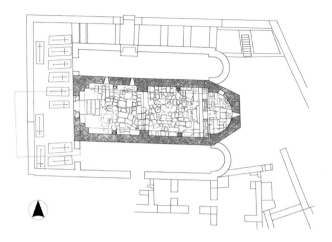

Figure 40. Plan of the Church of St. John, showing the central aisle flanked by two side aisles and graves in the narthex

(see Fig. 11). At that time it was a three-aisled building with a narthex (Fig. 40). From the Ottoman period to the time of its demolition only the central aisle remained in use (Fig. 41). The church stood on the east side of an old village road which led from the area of the museum parking lot past the west end of the South Stoa **19** to Acrocorinth **50**.

Corinth XVI (1957), pp. 61–66.

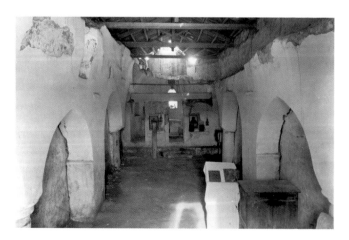

Figure 41. Interior of the Church of St. John in 1937, from the west

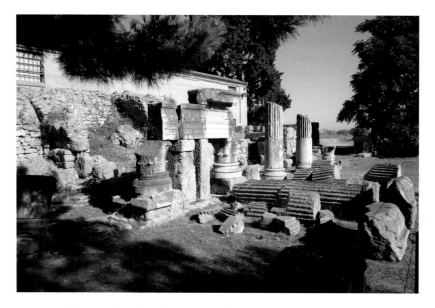

Figure 42. The West Shops from the south. In the background to the left is the museum.

⑰ WEST SHOPS

🔃 Return the short distance back up the hill and turn to face the museum. The remains of the West Shops are to the left and right of the modern wooden steps leading to the southern side of the museum and the open space in front of Temple E ❶.

The West Shops define the west end of the Roman Forum (Fig. 42). Dating to the third quarter of the 1st century A.D., they originally had two stories, with the lower story comprising 12 shops, six on either side of a broad staircase (now covered by modern wooden steps) ascending to the entrance of the precinct of Temple E. Each shop consisted of a vaulted chamber, parts of which still survive. These are best seen in the southern shops. The Corinthian capitals of the colonnade in front of the shops were particularly ornate. Each bears a mask in place of some of the acanthus leaves, variously carved to represent griffins, winged lions, sirens, and human faces Ⓜ. In the late 4th century A.D. an earthquake did sufficient damage to the colonnade that it had to be repaired. Three blocks preserve an inscription commemorating the patronage of the emperors Valentinian and Valens, who caused the repairs to be made (I-475, I-1224, I-1355, I-2000, I-2003). The inscription dates either to A.D. 364–375 or to A.D. 375–378, depending on

whether it refers to Valentinan I or Valentinian II. One piece of the inscription is displayed just south of the modern paved path, and the other pieces are located north of the wooden steps.

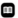

C. K. Williams II and O. Zervos, *Hesperia* 59 (1990), pp. 325–369.

⑱ FORUM SOUTHWEST

Farther south is a part of the site archaeologists named "Forum Southwest," a densely built-up area in the southwest corner of the Forum (Fig. 43). The area is largely inaccessible today.

Many levels of overlying construction have made this a particularly complicated area in which to discern building remains and phases. Yet several important structures are located here. The most significant are discussed below, in chronological order.

ℕ Because so much of the Forum Southwest is closed to visitors, the best route is to return to the modern path between Temples G and H, and turn right toward the South Stoa ⑲. Stop at the inner southwest corner of the Stoa, just in front of the roped-off area.

STELE SHRINE The Stele Shrine, built in the mid-6th century B.C., consists of a square *temenos* enclosed by a wall (Fig. 43). Inside the *temenos*, a *stele*, together with evidence of burnt offerings and an offering table, are indications of ritual, perhaps in honor of a local hero (Fig. 44). In the later 4th century B.C., the east side of the shrine was destroyed by the construction of the South Stoa ⑲, but it continued to be used, taking the stoa wall as the new boundary, until the end of the 3rd century B.C. or later (Fig. 45).

PENTAGONAL BUILDING The Pentagonal Building, built in the second or third quarter of the 5th century B.C., lies under the south tower of the West Shops ⑰. The foundations for the building were cut into the bedrock, which in places also served as the floor in the building's earliest phase. Later in the 5th century, when the Centaur Bath was built (see below), a narrow passage of 0.90 m allowed access between the buildings (Fig. 43). The function of the building is unknown.

Figure 43. Plan of the Forum Southwest in four phases

CA. 450 B.C.

AMPHORA PIT

PUNIC AMPHORA BUILDING

STELE SHRINE

0 5 10m.

CA. 400 B.C.

PENTAGONAL BUILDING

BUILDING V

Drain

CENTAUR BATH

5th-c. drain

BUILDING IV BUILDING III

STELE SHRINE

CA. 150 B.C.

COLUMNED HALL

Conduit

5th-c. drain

SOUTH STOA

STELE SHRINE

CA. A.D. 100

WEST SHOPS

LONG RECTANGULAR BUILDING

COLUMNS

ARCH

SOUTH STOA

ROMAN CELLAR BLDG.

Figure 44. The Stele Shrine, from the north. Near the bottom center are two nearly parallel stone supports for an offering table. To the left is the wall of the South Stoa that cut across the east side of the shrine.

Figure 45. Plan of the Stele Shrine, showing an amphora sunk into the ground in a level predating the shrine (580s or 570s B.C.), the two supports for the offering table dating to the first half of the 4th century B.C., and the wall of the South Stoa built in the later 4th century B.C.

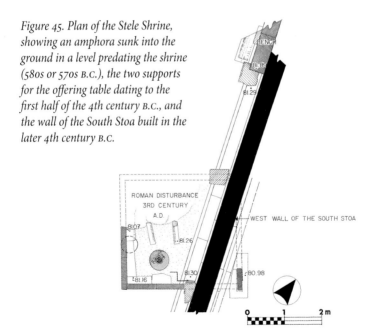

PUNIC AMPHORA BUILDING The Punic Amphora Building was a commercial establishment located near a busy intersection of three roads (Fig. 43). Dating to the mid-5th century B.C., the building contained many tons of fragments of transport amphoras of local Corinthian types, as well as imported Greek and non-Greek types Ⓜ. The imported Greek amphoras came from cities that exported excellent wine, while the non-Greek examples indicate that Corinth during this period was a hub in the trade of preserved fish from Spain. The fish was shipped in Punic amphoras made in Morocco.

CENTAUR BATH The Centaur Bath (Fig. 43) was built in the late 5th century B.C. and abandoned in the late 4th century B.C., making it one of the earliest public bath buildings in Greece. It is also the most elaborate bath of its period. The preserved remains include a furnace room, a network of water pipes, a central room with a mosaic floor, and, unusual for a bath, a dining room (Fig. 46). The pebble mosaic of the central room includes a central panel with a black and white wheel in a square frame, two corners of which survive (Fig. 47). One corner contains a depiction of a centaur, for which the bath is named; in the other is a donkey. The mosaic is one of the earliest figural pebble mosaics known from Greece.

COLUMNED HALL In the mid-2nd century B.C. a columned hall covered the eastern side of the Centaur Bath (Fig. 43). Fragments of two *abaci* (calculation devices) found on the floor of the building, one of which is inscribed "Public property of the Corinthians," suggest that this was perhaps a public accounting house or tax office (Fig. 48). Only the northern end, including three central piers, has been excavated.

ROMAN CELLAR BUILDING Large numbers of cooking pots, drinking cups, serving platters, and individual plates found in this structure indicate that it served as a public restaurant or tavern, dating to the late 1st century B.C. or the early 1st century A.D. (Figs. 47, 49). After suffering some damage in an earthquake ca. A.D. 22/3, the structure was repaired and continued in use until the 4th century A.D., though its function in this later phase is not clear.

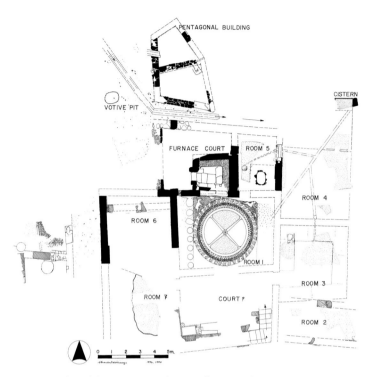

Figure 46. Plan of the Centaur Bath, partially restored

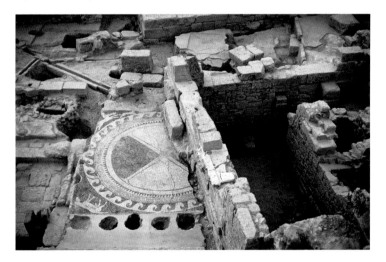

Figure 47. Mosaic of the central room of the Centaur Bath (cut by the Roman Cellar Building to the right)

Figure 48. Bottom surface of an abacus from the Columned Hall, with inscription marking it as public property of the city (I-1206)

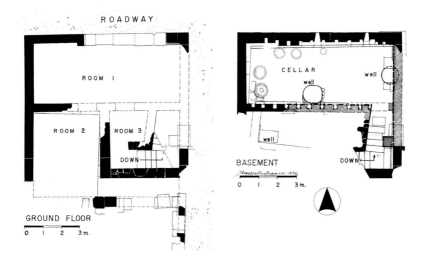

Figure 49. Plan of the Roman Cellar Building

COLUMNS, ARCH, AND LONG RECTANGULAR BUILDING Two monuments of interest are located at the northwestern corner of the South Stoa: a colonnade composed in part of reused columns from the Temple of Apollo ❹, and an arch spanning the road west of the stoa, which ascends toward Acrocorinth ❺⓿ (Fig. 43). Limestone paving slabs from the road are visible today, resting on sections of the road's foundations west of the South Stoa. The arch marks a slight reorientation of this area: its foundations were built over the stylobate of the colonnade of Archaic columns, which were repurposed from the Temple of Apollo following a remodeling of the temple in the Roman period. The foundations of the arch are visible behind the

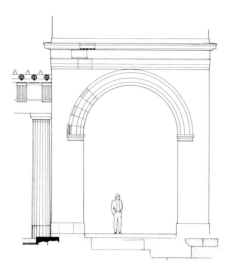

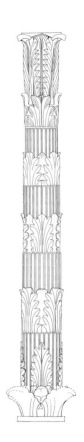

Figure 50 (above). Restored elevation of the arch west of the South Stoa, from the north

Figure 51 (right). Restored drawing of an acanthus column found near the Long Rectangular Building

southernmost column, at an angle toward the northwest. The arch consisted of a single portal ca. 4.50 m wide (Fig. 50).

West of the arch and contemporary with it, the Long Rectangular Building (Fig. 43) was built in the late 1st century A.D. and continued in use—at least its western end in a much-altered state—through the 6th century A.D. Despite its elongated shape, this building was not a stoa but a fully enclosed structure, and it might have supported an inscribed marble epistyle (I-1974-2) dating to the Antonine period (mid- to late 2nd century A.D.). Fragments of acanthus columns Ⓜ found north of the building suggest that one free-standing column may have stood near the east end and another near the west end of the building (Fig. 51).

Stele Shrine: C. K. Williams II, *Hesperia* 47 (1978), pp. 1–12. **Pentagonal Building**: C. K. Williams II and J. Fisher, *Hesperia* 45 (1976), p. 108. **Punic Amphora Building**:

M. Z. Munn in *Corinth* XX (2003), pp. 195–218; C. K. Williams II, *Hesperia* 49 (1980), pp. 107–134. **Centaur Bath**: C. K. Williams II, *Hesperia* 46 (1977), pp. 40–81. **Columned Hall**: C. K. Williams II, *Hesperia* 46 (1977), pp. 40–81. **Roman Cellar Building**: K. S. Wright, *Hesperia* 49 (1980), pp. 135–177; K. W. Slane, *Hesperia* 55 (1986), pp. 271–318. **Colonnade and arch**: *Corinth* I.4 (1954), p. 155; C. A. Pfaff in *Corinth* XX (2003), p. 114; C. K. Williams II and J. E. Fisher, *Hesperia* 45 (1976), pp. 127–137. **Inscribed epistyle**: C. K. Williams II and J. E. Fisher, *Hesperia* 44 (1975), no. 20.

⑲ SOUTH STOA

🔊 Begin the visit to the South Stoa at the southwest corner, in front of the roped-off area.

The South Stoa, with a length of ca. 165 m and a width of ca. 25 m, was the largest stoa in Greece at the time of its construction, ca. 300 B.C. (Fig. 52). The facade was lined with 71 Doric columns, and behind it was an internal colonnade of 34 Ionic columns (Fig. 53). Some of the Doric column drums are displayed today on the foundations, while many of the Ionic column bases are preserved along the length of the stoa. The columns supported an open porch behind which were 33 two-story units, each including a front room and a larger back room. All but two of the front rooms contained a well. Several meters beneath the South Stoa and to the south of the wells was an aqueduct taking water down to the Fountain of Peirene �37. The wells in the rooms connected to the aqueduct by means of small tunnels. On the basis of pottery found in these rooms and in the wells, it is clear that eating and drinking took place in many of the units, while others had a more commercial function. Some rooms might have been shops and others dining areas, and it has been suggested that those on the second floor might have been used for sleeping or drinking. The precise form of the upstairs rooms remains unknown.

During the Roman period, the South Stoa underwent gradual alterations, and over time the form of the units changed. In places,

Figure 52. Plan of the South Stoa in its original phase

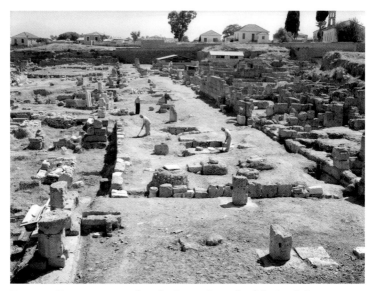

Figure 53. Excavators at work in the Ionic colonnade of the South Stoa in 1952, from the west

the original construction was maintained, while in others completely new architectural arrangements were introduced (Fig. 54).

Beginning at the western end of the stoa, the first three rooms retained their original plans and perhaps their original functions as shops. One of the wells is on view in the third room.

Beyond these rooms is a Roman latrine (Fig. 54: J), which consists of an entrance room leading to a larger room to the south, where a colonnade supported the roof. Several fragments of marble slabs with circular holes found in the area, as well as a channel in the floor along the walls, indicate that this room had seats around all four sides, and that the waste was drained from the room by the channel. Several late graves dating to the 8th or 9th century A.D. were cut into the floor of the entrance room.

To the east of the latrine is a bath, which dates to the 5th century A.D. (Fig. 54: I). The bath was entered through a large *frigidarium*, where a section of the original 4th-century B.C. wall of the stoa is preserved up to two courses above the orthostate. The *frigidarium*, which also served as an *apodyterium* (dressing room), had two small pools on the east side. A sequence of three connected rooms, some

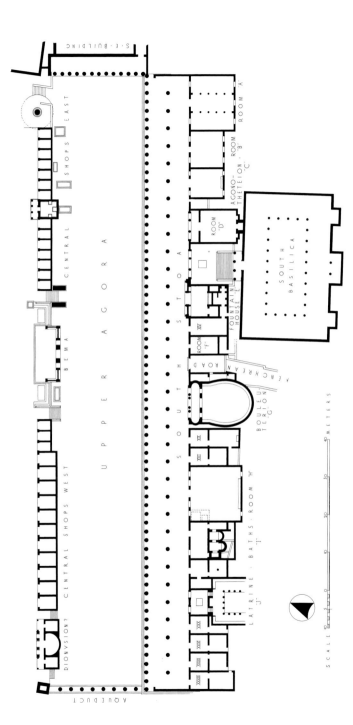

Figure 54. Plan of the South Stoa with Roman modifications. To the north are the Bema and the Central Shops.

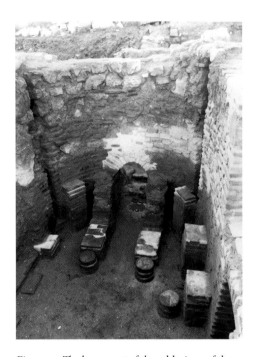

Figure 55. The hypocaust of the caldarium *of the bath in the South Stoa in 1937, from the north. The arch at the back of the room, partially restored, opened onto a small room to the south that contained a furnace.*

with pools, lay to the south, heated by furnaces in the service areas to the south and west (Fig. 55).

Next is the so-called Marble Room, a large hall covered with revetments of gray, white, and pink marble, and with a floor of thin marble slabs (Figs. 54: H, 56). Along the base of the wall is a molding of white marble. The function of this lavish room is unclear.

The next two rooms to the east perhaps served as a Serapeum, as suggested by a head of Serapis (a Greco-Egyptian god) found in this area (Fig. 57) Ⓜ.

An elliptical structure near the center of the South Stoa has been identified as a *bouleuterion* (council house) (Figs. 54: G, 58). A shallow porch with two pairs of columns on the facade today has a *togatus* (marble togate statue) on display. From the porch, three doorways lead

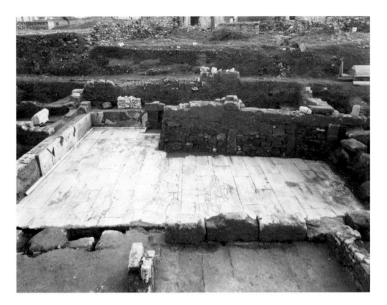

Figure 56. The Marble Room in the South Stoa in 1936, from the north. Visible in the rear of the room is the base of a dais *(long bench) built against the south wall.*

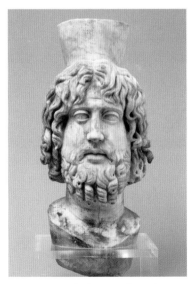

Figure 57. Head of Serapis from the South Stoa

to a large apsidal room. Several pieces of marble benches, some visible at the back of the room, suggest that a continuous bench lined the interior wall of the structure. The Bouleuterion may date to the late 2nd century A.D.

To the east of the Bouleuterion is a road leading out of the Forum and toward the Kenchrean Gate, passing through a once densely populated area of the city. The road is roughly aligned with the Lechaion Road 🟢 to the north of the Forum, and is paved with heavy limestone blocks.

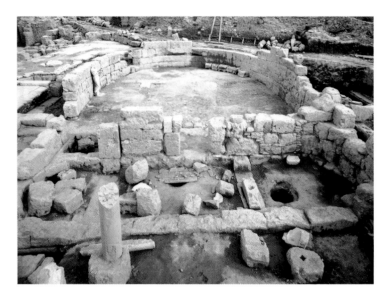

Figure 58. The Bouleuterion in the South Stoa in 1935, from the north

East of the road is a fountain house (Fig. 54: E) currently covered by a shed roof. The fountain consists of a large chamber with a basin flanked by two alcoves, and it was lavishly decorated with marble revetments of many colors. Several pieces of marble are preserved today, including a base molding ornately carved with laurel swags or myrtle leaves. Behind the chamber is a service area where water was collected.

To the east of the fountain house is the entrance to the South Basilica **20**, which is described below.

The remaining rooms to the east of the entrance to the South Basilica have been identified as administrative offices. The architectural form of the rooms likely dates to the earliest Roman renovation of the stoa during the 1st century A.D. One of these rooms (Fig. 54: C, protected by a modern shed) contains a well-preserved mosaic floor depicting a victorious athlete carrying a palm branch and standing before a seated and partially draped female deity (Fig. 59). The mosaic has recently been dated to the Severan period (A.D. 193–235), and perhaps indicates that the room functioned at this time as an *agonotheteion,* the office of the *agonothetai,* administrators of the Isthmian Games. Two inscriptions honoring *agonothetai,* one found in the South Stoa, are on display in the museum (I-34, I-1216) **M**.

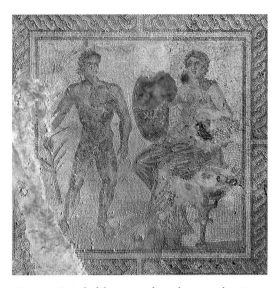

Figure 59. Detail of the mosaic from the agonotheteion *in the South Stoa*

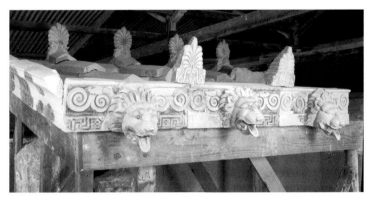

Figure 60. Reconstructed section of the roof of the South Stoa

To help visitors better visualize what it would have looked like, a section of the roof of the South Stoa in its original form was reconstructed, including portions of the simas, lion-head waterspouts, and akroterial palmettes (Fig. 60). This display has since been dismantled.

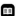

Corinth I.4 (1954).

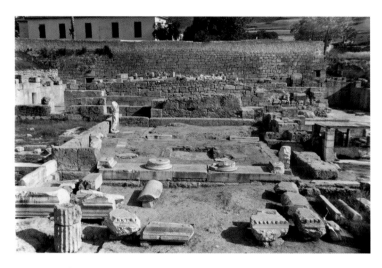

Figure 61. The entrance to the South Basilica in 1947, from the north

⑳ SOUTH BASILICA

The South Basilica is located immediately south of the South Stoa ⑲, and dates to the second or third quarter of the 1st century A.D. The entrance to the basilica from the South Stoa colonnade was through a monumental *distyle in antis* facade with Corinthian columns between rooms D and E (Figs. 54, 61, 62). This entrance led to a court, and from there a broad marble-reveted concrete staircase led up to a large room with Corinthian columns on four sides. The Corinthian colonnade supported a clerestory over the central area. Beneath the aisles that surround the colonnade was a cryptoporticus (underground corridor), which was used for storage. Visible today are the column bases of the facade and the bases for the flanking antae, and behind these the basement level of the basilica, including the floor of the crypto-porticus (Figs. 63, 64).

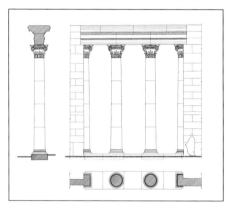

Figure 62. Elevation of the entrance to the South Basilica

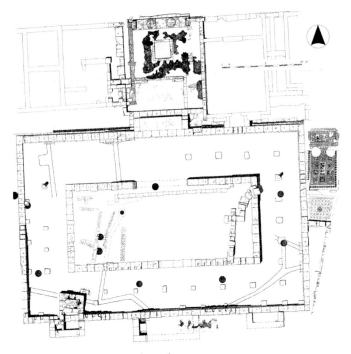

Figure 63. State plan of the South Basilica

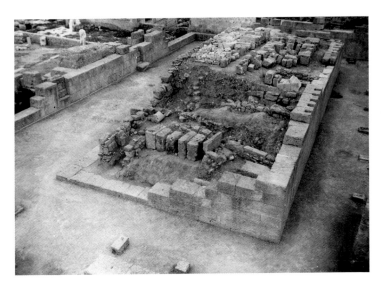

Figure 64. The South Basilica in 1947, from the southwest

The same earthquake that damaged the colonnade of the West Shops **17** in the late 4th century A.D. also seems to have damaged the entrance to the basilica. An inscription (I-1499) identifies the same emperors, either Valentinian I or II, and Valens (A.D. 364–375 or A.D. 375–378), as benefactors of the reconstruction work. The structure was no longer standing in the 5th century A.D. when a house was built over the eastern end of the cryptoporticus.

<div align="center">

Corinth I.5 (1960), pp. 58–77.

</div>

21 SOUTHEAST BUILDING

N Follow the path past the shed at the east end of the South Stoa. Where the path turns north, a portion of the steps of the portico of the Southeast Building, including one column base, is visible at a right angle to the stoa.

The columned portico that closed the east end of the Forum served as the entrance to the Southeast Building (Plan 6). In its earliest form, probably dating to the second half of the 1st century B.C., the building had two suites of three rooms built symmetrically along the axis of a central corridor (Fig. 65). It has been suggested that this might have been either an archive building or a library. Fragments of a fresco were found here showing the myth of Briareos judging a contest between Helios and Poseidon for control of Corinth (Paus. 2.1.6).

The building was partially demolished to make space for the Julian Basilica to the north in the first decade of the 1st century A.D. It was rebuilt on a different plan in the second quarter of the 1st century

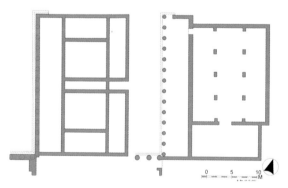

Figure 65. Restored plans of the Southeast Building: second half of the 1st century B.C. (left) and second quarter of the 1st century A.D (right)

(Fig. 65). A door from the north end of a portico gave admittance to a room divided into three aisles by interior supports. At the south end was a transverse room entered from the central aisle. An inscription found during the excavation of the building (I-647) suggests that it was erected by the same Cnaeus Babbius Philinus who built the Babbius Monument and Fountain of Poseidon at the west end of the Forum ⓯. Three fragments of an inscribed marble epistyle (I-36 + I-932, I-677) displayed in the front of the building might once have belonged to it; if so, they provide further evidence that the donor was Babbius, identified here as both *pontifex* and *duumvir*.

Corinth I.5 (1960), pp. 1–31; *Corinth* VIII.2 (1931), nos. 100, 122.

㉒ CIRCULAR MONUMENT

 Follow the path to the north, stopping upon reaching the Circular Monument to the left.

The original Circular Monument may date to the Classical period; the preserved structure is Roman. In its earliest Roman phase it consisted of a raised circular platform, 2 m high and 9 m in diameter, supporting a limestone column drum 2.15 m in diameter. The platform was subsequently modified on its north and west sides and given a larger, rectangular foundation on these two sides (Fig. 66). In this form, the walls received marble revetment, still partly preserved. Later, when the Central Shops ㉘ were constructed, the west side was cut back to accommodate the easternmost shop. Oscar Broneer, who believed the original column was much taller, suggested this monument was one depicted on Corinthian coins of the Antonine and Severan periods. Today the monument's foundations and the lowest column drum are visible.

The Circular Monument was excavated in 1892 and 1896, but it is actually one of the earliest monuments at Corinth to have been recorded. A second, upper member of the column was drawn by Sebastian Ittar, architect to Lord Elgin, on a visit to Corinth in 1802. On the basis of this evidence, William Dinsmoor Sr. restored a much shorter column and dissociated the monument from that shown on the coins.

Corinth I.3 (1951), pp. 79–85; C. K. Williams II and P. Russell, *Hesperia* 50 (1981), pp. 15–21.

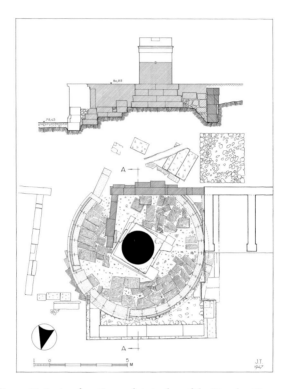

Figure 66. Restored section and state plan of the Circular Monument

㉓ RACECOURSE AND PLATFORM

In front of the Circular Monument are the remains of two successive *stadia* (racecourses), which lie beneath the Roman Forum. The *apheteria* (starting blocks) of both tracks lie directly to the west of the Julian Basilica ㉔ (Fig. 67), and portions of the water channels that flanked the Hellenistic track are visible most prominently by the Quadriga Base ㉜. The earlier starting line, which may date to the 5th century B.C., is curved to give all runners an equal chance at the start of the race, and numbered positions for the runners were painted in red on the blocks. The later Hellenistic starting line is oriented north–south, without a curve. The differing orientation of the two phases shows that the line of the racecourse changed in the Hellenistic period from a southwesterly direction to a more westerly line (Map 1). The total length of the racecourses at Corinth is unknown; in ancient Greece, the length of a stade ranged from 177 to 192 m depending on date and geographical location.

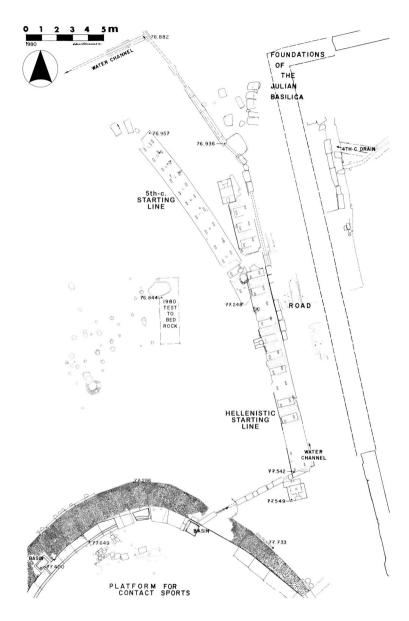

Figure 67. State plan of the northeast corner of the Forum, showing the starting lines of the racecourses dating to the 5th century B.C. and the Hellenistic period, as well as the platform for contact sports to the south

Both starting lines can be distinguished on the site today. The Hellenistic starting line, with its individual toe-holds, is most easily seen running roughly parallel to the front of the Julian Basilica. At the north and south ends of the line are the two bases of the *hysplex*, a starting gate mechanism. The earlier starting line emerges from beneath the Hellenistic line and curves to the northwest.

Another part of this sports complex is a parabolic platform just south of the racecourse (Fig. 67), used for contact sports, such as wrestling, boxing, and the *pankration*, an all-in competition combining wrestling and boxing. Along the north side of the platform is a cobbled path, partly covered by the later Hellenistic racecourse; this path is visible north of the Circular Monument. Three basins and a water channel at the edge of the platform provided water for spectators watching the events on the platform, as well as on the racecourse in front of it. The channel is particularly well-preserved on the northeast side of the platform, behind a portion of one of the water basins.

C. K. Williams II and P. Russell, *Hesperia* 50 (1981), pp. 1–21.

㉔ JULIAN BASILICA

The Julian Basilica closes the east end of the Roman Forum, along with the Southeast Building ㉑. It was a two-story structure with a cryptoporticus below and a peristyle hall above (Figs. 68, 69). The southern cryptoporticus, with its later vaulted arch, is impressive when viewed from the east side of the Circular Monument ㉒. The basilica was built in the early years of the 1st century A.D. of locally quarried oolitic limestone. Statues of the Julio-Claudian family were displayed within the building, including the emperor Augustus, his grandsons, Gaius and Lucius (Fig. 70), and Nero, among others Ⓜ. The building probably served as a law court, and perhaps as the seat of the imperial cult.

During the mid-1st century A.D. the interior was redecorated with marble revetment, some of which, including part of an inscription referring to its placement, was reused in renovations in the Antonine period. Blocks from the basilica were finally reused in a later wall immediately to the east.

Corinth I.5 (1960), pp. 35–57; P. D. Scotton, *Hesperia* 74 (2005), pp. 95–100.

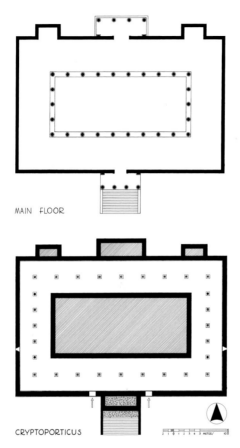

MAIN FLOOR

CRYPTOPORTICUS

Figure 68. Restored plan of the Julian Basilica

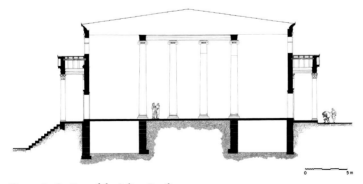

Figure 69. Section of the Julian Basilica

Figure 70. The statue of Gaius Caesar as found in the east aisle of the Julian Basilica in 1914

㉕ AUGUSTALES MONUMENT

🡒 Walk along the parabolic platform toward the west, following the cobbled path. To the right, opposite two modern steps ascending to the Forum, is the Augustales Monument.

Located near the center of the eastern half of the Forum, the Augustales Monument consisted of a limestone base with an inscribed marble block above, supporting a bronze statue of the deified Augustus (Fig. 71). The inscription (I-1750) indicates that the Augustales, a group generally charged with celebrating the imperial cult, set up the monument, likely in the early 1st century A.D.

Corinth I.3 (1951), pp. 142–143; *Corinth* VIII.3 (1966), no. 53.

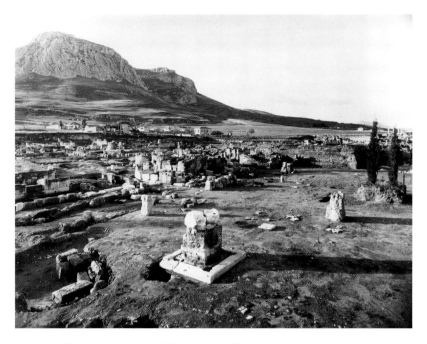

Figure 71. The Forum in 1937, with the remains of the Augustales Monument in the foreground

26 HEROON OF THE CROSSROADS

Continue ca. 10 m past the Augustales Monument toward the west. The Heroon is below ground level on the left, just in front of the Bema.

The Heroon of the Crossroads is a small, open-air *temenos* located northeast of the Bema. The *temenos* was built immediately over four Protogeometric graves dating to the 10th century B.C., and seems to have been the setting for a hero cult established at these graves (Fig. 72). Evidence provided by pottery indicates that the Heroon was built in the second or third quarter of the 6th century B.C., and continued in use until 146 B.C.

Today, the graves are no longer visible, but their locations are shown with gray gravel. In addition, a portion of the *temenos* wall has been restored, though its height is purely conjectural.

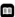

C. K. Williams II, *Hesperia* 50 (1981), pp. 410–411; C. A. Pfaff in *Corinth* XX (2003), p. 128.

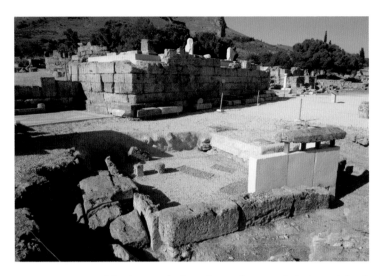

Figure 72. Heroon of the Crossroads, from the northeast, with the Bema behind

㉗ BEMA

🔼 The Bema rises above and to the south of the Heroon of the Crossroads.

The Bema was a complex marble structure dating from the middle of the 1st century A.D. that dominated this part of the Forum at Corinth. It took the form of an open propylon with a Π-shaped ground plan, which stood on a rectangular podium measuring 15.6 × 7.2 m (Fig. 73). This podium had a krepidoma with two steps and it projected 3 m above the level of the Forum to the north. Its superstructure consisted of eight pillars, three at each corner linked by walls lined with benches, and two across the front. The podium was flanked at a lower level by two unroofed exedras with benches on two of their three sides (Fig. 74). Beside each exedra was a marble staircase leading up to the terrace to the south. Parts of the Bema's walls and steps, as well as the floors of the exedras, have been restored.

The Bema was the venue for public ceremonies, in which the assembled citizens were addressed by the proconsul of Corinth. It is thought to be the Bema mentioned in the Acts of the Apostles (see p. 93).

In the 5th century A.D., the rectangular exedras were modified by the addition of parapet walls on their northern side to enclose the unroofed spaces. Traces of waterproof cement preserved on the

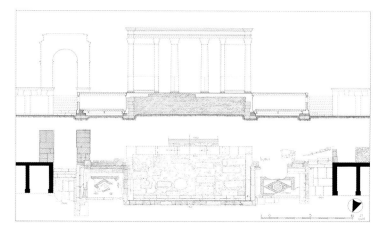

Figure 73. Restored elevation (above) and plan (below) of the Bema complex

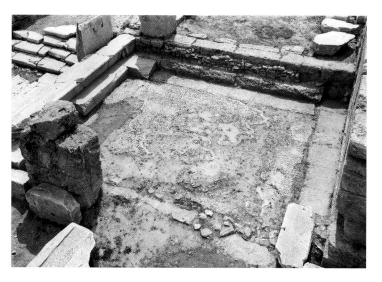

Figure 74. The exedra to the east of the Bema in 1947, from the northwest

interior walls indicate that the spaces were transformed into public fountains in which the water level would have been as high as the benches in the original structure.

In the Byzantine period, a Christian church with at least two phases was built on the ruins of the Bema. The second phase was

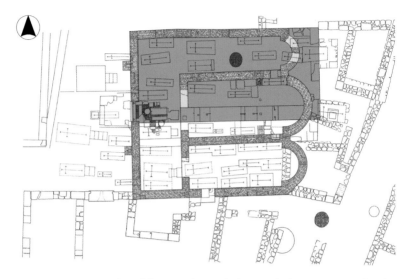

Figure 75. State plan of the Bema (orange), showing the later Byzantine church (yellow) above the Roman remains and the numerous Christian graves located in and around the church

a three-aisled basilica (11th–12th century A.D.) (Fig. 75). Extending the length of the Forum on both sides of the Bema were the Central Shops **28**.

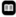

Bema: *Corinth* I.3 (1951), pp. 91–111. **Fountains**: *Corinth* XVI (1957), pp. 12–14.

28 CENTRAL SHOPS

The Central Shops run from the Circular Monument **22** to the Bema **27**, and from the Bema to the colonnade of reused Archaic columns **18** extending north from the west end of the South Stoa **19** (Fig 76). The shops separated the Forum proper, also referred to as the lower Forum, from the upper Forum to the south, in front of the South Stoa. The eastern series consists of 15 shops. The central structure in this group is larger than the others, and had a tetrastyle portico. The interior was furnished with a marble floor and three bases, one along each wall, which probably supported statues (Fig. 77). It might have been a cult room or office. The western series of rooms consists of 14 shops culminating at the west end in a structure with a porch in

Figure 76. State plan (bottom), restored plan (middle), and restored elevation (top) of the Central Shops. The South Stoa is shown in the background of the elevation.

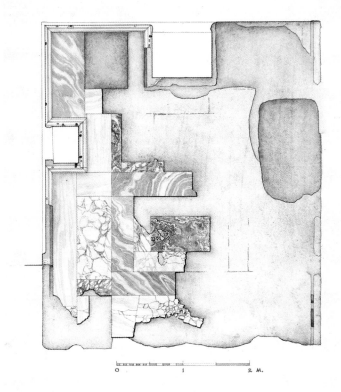

The
MARBLE ROOM

Figure 77. State plan of the marble pavement within the larger room at the center of the eastern series of Central Shops

front of two rectangular rooms flanking a large semicircular room. This building was formerly called the "Dionysion," but it is more likely to have been used for a cult of Hermes, the market god.

In the 5th century A.D. the shops were demolished and replaced by a staircase uniting the upper and lower levels of the Forum. This stair is the widest known in the ancient world.

Corinth I.3 (1951), pp. 112–117; *Corinth* XVI (1957), pp. 12–13.

THE APOSTLE PAUL

The apostle Paul (Fig. 78) first visited Corinth during his second missionary journey, between A.D. 50 and 52. During this visit, Paul was summoned before the proconsul Lucius Junius Gallio in the summer of A.D. 51, as described in Acts 18:12–17. The Jews of Corinth had charged Paul with acting contrary to Jewish law. Gallio

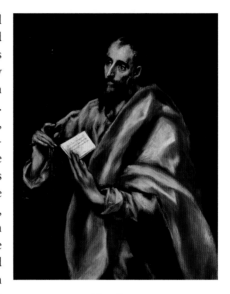

Figure 78. St. Paul *by El Greco*

refused to become involved on a question of Jewish law and dismissed the charges. After some 18 months in Corinth, Paul departed with Aquila and Priscilla, a couple who had hosted him during his stay in the city, and who traveled and worked with him on subsequent missionary journeys. Paul then moved his ministry to Ephesos, where he stayed for three years. From Ephesos, Paul sent a letter to the church in Corinth (1 Corinthians), admonishing them in particular about divisions in the church, the persistence of pagan beliefs, and immorality. In a second letter to the Corinth church (2 Corinthians), this one written while in Macedonia, Paul describes his next visit to the city, in A.D. 56, during which he had a much less pleasant time (2 Cor 2:1). He visited Corinth for a final time a short while later. Paul's relationship with the church in Corinth might have been a challenging one, but it also resulted in one of his most successful ministries.

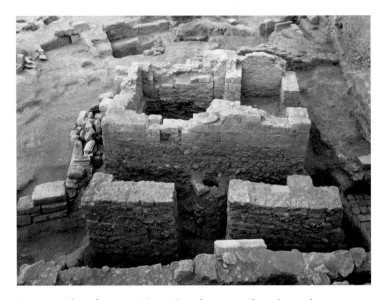

Figure 79. The 12th-century Tower Complex in 1937, from the north

㉙ TOWER COMPLEX

Standing prominently to the southwest of the Bema are several courses of foundations for a tower surrounded by a few rooms, dating to the 12th century A.D. (Fig. 79). The function of this complex is unknown.

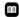

Corinth XVI (1957), pp. 68–70.

㉚ SOUTH BATH AND UNDERGROUND SHRINE

A bath, often called the South Bath, dating probably to the 11th century A.D., is located south of the Tower Complex. The preserved remains, which are difficult to appreciate today, include a series of basins lined with waterproof cement, connected to a large room with a hypocaust floor (Fig. 80).

Approximately 10 m southeast of the Tower Complex, and in line with the steps west of the Bema, are the remains of the Underground Shrine, constructed in the 6th century B.C. Today reburied and no longer visible, the structure consisted of a single room, 2.8 × 3.0 m, cut ca. 1 m into the bedrock, with an entrance ramp on the west side and a single column *in antis* on the facade (Fig. 81). The shrine might have

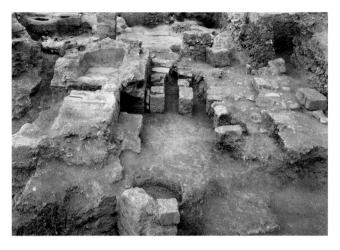

Figure 80. The South Bath in 1937, from the north. Several pillar sup-ports of the hypocaust floor are visible.

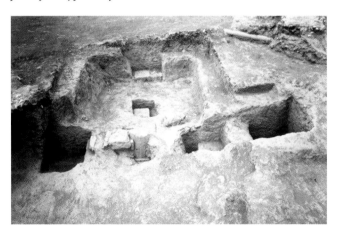

Figure 81. The Underground Shrine just after its excavation in 1937, from the northwest. At center, the single column on the facade is visible.

had a roof, supported in part by a column set into a deep rectangular cutting in the center of the building. This may have been the site of a hero cult connected to Geometric graves located nearby.

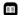

South Bath: *Corinth* XVI (1957), pp. 70–71; *Corinth* I.4 (1954), p. 145. **Underground Shrine**: C. A. Pfaff in *Corinth* XX (2003), p. 127.

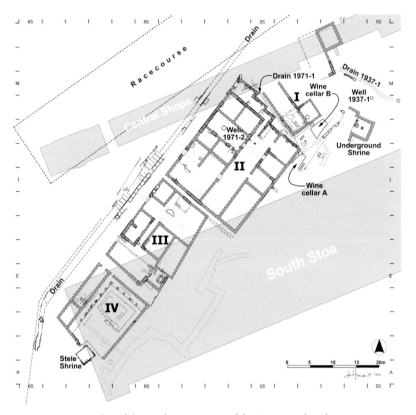

Figure 82. Plan of the southwestern part of the Forum in the 5th century B.C., showing the Underground Shrine, Buildings I–IV, and the Stele Shrine

③① BUILDINGS I–IV

Buildings I–IV are a line of four structures extant in the late 5th and 4th centuries B.C., flanking the Classical racecourse ㉓ (Fig. 82). The location and contents of these four buildings suggest that they served a public and religious function rather than a domestic one. The walls of the buildings are difficult to make out today, but they can be identified by their northeast–southwest orientation.

Although parts of Building I were obliterated by the construction of the Central Shops ㉘, the preserved plan is L-shaped, with a small dining room at the northeast corner. One artifact that may be related to its original use is the base of a statuette dedicated by Timokrates to Artemis Kori(n)thos.

Building II sprawls over a large area of 440 m². A central court divides the building into two uneven parts: a complex of seven (possibly nine) rooms on the northwest side and a group of five rooms on the southeast side. The entrance was through a vestibule and corridor at the north corner. Its precise function is unknown, but the building seems to have had some civic purpose.

Building III (the so-called Tavern of Aphrodite) is a rectangular complex consisting of two courtyards separated by a range of four rooms and linked by a corridor. Each of the courtyards had an exterior door marked with wheel ruts. The building takes its nickname from the objects found within it, which include pottery largely used for drinking and large numbers of terracotta figurines. All the female figurines represent a goddess holding a dove, an attribute of Aphrodite.

Building IV consists of a courtyard with a large off-center "cellar" on its southeast side and a range of rooms on the northwest side. Along the southeast and northwest sides of the court was a colonnade supporting a pitched cloister roof. Outside the building to the west was a small Stele Shrine ⑱ that continued in use after the construction of the South Stoa ⑲.

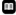

C. K. Williams II and J. E. Fisher, *Hesperia* 41 (1972), pp. 143–172; C. K. Williams II, *Hesperia* 47 (1978), pp. 12–15; C. K. Williams II, *Hesperia* 48 (1979), pp. 125–140.

㉜ QUADRIGA BASE

🔁 Across the Forum opposite the tower is the Quadriga Base. It has been partly covered by later structures, and is ca. 0.70 m below the ground level of the Forum.

A poros monument base, prominently located on the southern edge of the Hellenistic racecourse, held a bronze *quadriga*, a group of four horses leading a chariot, and perhaps a groom (Fig. 83). Although the top plinth of the base is not preserved, dowel cuttings for the bronze figures cut deeply into the uppermost course of poros blocks beneath it and allow the restoration of the *quadriga* (Fig. 84). The monument, dating to the early 4th century B.C., is earlier than the racecourse, and pottery found in fill above indicates that it was dismantled after 146 B.C.

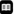

C. K. Williams II, *Hesperia* 39 (1970), pp. 6–9.

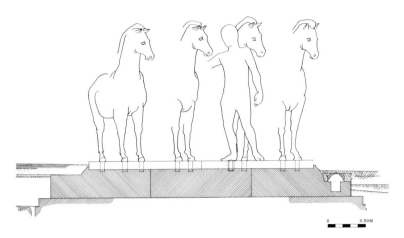

Figure 83. Restored drawing of the Quadriga Base, including the four horses and a groom

Figure 84. State plan of the Quadriga Base, with dowel holes for the attachment of the bronze horses of the quadriga

VIEW OF THE FORUM

TOPOGRAPHICAL NOTE 3

🧭 Proceed to the northeast, toward the Lechaion Road **36**. Just to the left are a large pine tree and a bench.

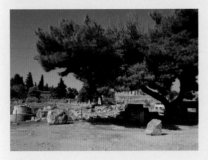

Figure 85. Pine tree in the Forum

A pine tree and a bench on the north side of the Forum (Fig. 85) provide an excellent place to pause and look at the Forum as a whole. Visible immediately to the north are the foundations of the Captives' Facade **34**, with the Northwest Shops **14** just to the west and the columns of the Temple of Apollo **4** rising above (Fig. 86). Further to the west is the Sacred Spring **33**, and beyond it the temples at the west end of the Forum **15**, with Temple E **1** and the West Shops **17** behind them. To the south, in the immediate foreground is the Quadriga Base **32**, and behind it are the Central Shops **28** with the Bema **27** in the middle (see Fig. 76). Looming above is Acrocorinth **50**.

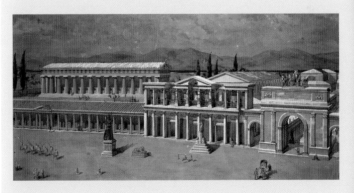

Figure 86. Restored drawing of the northern side of the Forum. From left to right are the Northwest Shops with the Temple of Apollo behind, the Captives' Facade in front of the Lechaion Road Basilica, and the Lechaion Road Propylaia.

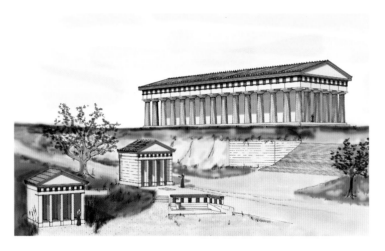

Figure 87. Restored drawing of the Sacred Spring in the 5th century B.C.

㉝ SACRED SPRING

The Sacred Spring (Fig. 87) was a sanctuary rather than a public water source. The Sacred Spring complex has a long history lasting from the early 8th century B.C. into the Hellenistic period with several phases of extensive remodeling. The original simple springhouse was embellished with interconnecting architectural features in the late 6th century B.C. On the lower level it consisted of an underground spring-house with interior supports, lion-head waterspouts (Fig. 88) Ⓜ, and a three-column facade. As the ground level rose, the facade was closed off, and the spring was accessed by a staircase. In front of the spring was an extensive open area containing an earth altar and wooden bleachers for seating. This lower stage was separated from the area to the west by a triglyph-and-metope wall, the most prominent element of the Sacred Spring visible today (Fig. 89). The upper area contained a small apsidal building (Fig. 90). For the viewer below, this building, with its three-column facade, made a visual link with the lower foun-tain. A water channel and a crawl space physically linked the apsidal building to the lower area by a secret door in the triglyph-and-metope wall. A boundary stone (*horos*) from the Sacred Spring dates to the 5th century B.C. Ⓜ.

The space of the Sacred Spring was probably used for proces-sions, sacrifices, drama performances, music, and dance. One school

Figure 88. Interior of the springhouse in 1933, with the northern lion-head waterspout still in situ

Figure 89. The triglyph-and-metope wall of the Sacred Spring in 1900, with the entrance to the underground springhouse

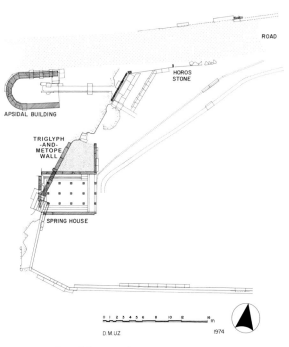

Figure 90. Plan of the Sacred Spring, ca. 450 B.C.

of thought connects the spring, the apsidal building, and the Temple of Apollo above with an oracular cult. More recently it has been suggested that Kotyto, one of the four daughters of Timandros burned by the Dorians in the Temple of Athena, was commemorated here. Her festival involved young men dressed as women dancing to orgiastic music. One component of the rite was immersion or initiation in water.

Next to the triglyph-and-metope wall is a statue base inscribed "Lysippos made it" (Fig. 91). Lysippos was a sculptor from the neighboring city of Sikyon whose work earned him international fame in the Hellenistic and Roman periods. This base would have held a bronze statue of a standing male; it was only one of a series of honorific statue bases that stood in this area.

Sacred Spring: *Corinth* I.6 (1964), pp. 116–199; C. K. Williams II, *Hesperia* 28 (1969), pp. 1–63; C. K. Williams II and J. E. Fisher, *Hesperia* 40 (1971), pp. 1–51. **Lysippos base**: *Corinth* VIII.1 (1931), no. 34.

Figure 91. Statue base inscribed with the name of the artist Lysippos (I-29)

34 CAPTIVES' FACADE

An ornate two-story facade on the south side of the Lechaion Road Basilica 44 faces south toward the Forum between the Northwest Shops 14 and the Propylaia 35. The upper story consisted of a row of six over-life-size figures of captive barbarians standing against Corinthian piers (Fig. 92) M. The monument has been thought to commemorate the victories of the emperor Septimius Severus over the Parthians in A.D. 197.

On the site today is a reconstruction of parts of the facade's superstructure, including a corner of the pediment and an architrave with a lotus-and-palmette frieze above.

Figure 92. Statue of a barbarian from the Captives' Facade

Corinth I.2 (1941), pp. 55–88; *Corinth* IX (1931), pp. 101–107.

㉟ PROPYLAIA

The Propylaia was a monumental arch at the entrance to the Forum from the Lechaion Road ㊱. Its foundations are visible on either side of the modern wooden platform.

Study of the foundations and architectural remains has indicated that the Propylaia had three phases. In its first phase, perhaps dating to the early 1st century A.D., it consisted of three archways: a large central one flanked by two smaller ones. In its second phase, perhaps near the end of the 1st century A.D., it became a large, single-bayed arch with a much deeper vault and pylons, approached by a central flight of steps. Fragments of relief sculpture found in the area suggest that later during this phase, perhaps ca. A.D. 117, the arch may have been decorated with sculptural panels representing imperial sacrifice, barbarian submission, and captured weapons. At the time of Pausanias's visit to Corinth later in the 2nd century A.D., the Propylaia was crowned by gilded bronze chariots of Helios and Phaethon (Paus. 2.3.2; see Fig. 86). In the Propylaia's third phase, sometime in the Late Roman period, crosswalls and a platform to the east were built.

Corinth I.1 (1932), pp. 159–192; C. M. Edwards, *Hesperia* 63 (1994), pp. 263–308.

㊱ LECHAION ROAD

The line of the Lechaion Road existed as early as the Classical period, and it was reestablished by the Romans as the main north–south artery, the *cardo maximus,* of the Roman city. The Lechaion Road linked the Forum of Corinth with the harbor of Lechaion on the Corinthian Gulf, 3 km to the north. In the time of Augustus, it was unpaved and open to wheeled traffic. The road was paved with limestone slabs in the second half of the 1st century A.D., when traffic was confined to pedestrians. At this period there were sidewalks on either side of the road with gutters to carry away rainwater. Rows of shops were created on both sides of the road, and colonnades and bases for dedications were set between the shops and the pavement. The road began to lose its importance from the 10th century A.D. onward and was finally abandoned after the earthquake of 1858.

On the west side of the Lechaion Road is a row of 16 small shops. To the west of these shops, the most important building was a large

VIEW DOWN THE LECHAION ROAD

The platform of the Propylaia provides a useful oveview of the Lechaion Road and the monuments that face it (Fig. 93). To the east of the Propylaia is the Fountain of Peirene ③⑦. The curving walls of the apses were added to the structure in late antiquity, and large marble columns, reused from a classical building, were added to the southern facade in the Late Antique period. Pausing for a quiet moment here will allow one to hear the water still running through underground conduits. To the west along the Lechaion Road are shops, and behind these evidence of the quarry that cut away the east side of Temple Hill ⑪. Just beyond the exit on the west side of the road is the Old Museum, while to the right is the village square. The exit from the archaeological site lies at the north end of this well-preserved stretch of road.

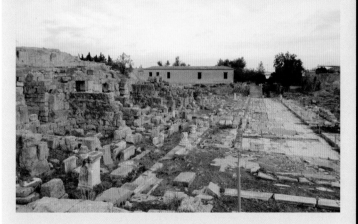

Figure 93. The Lechaion Road, with the Old Museum to the left and the village square to the right just outside the site exit

TOPOGRAPHICAL NOTE 4

Roman basilica , which was probably used as a courthouse. Its southern side, facing the main area of the Forum, was adorned by the Captives' Facade ㉞, with colossal figures of barbarian prisoners-of-war (late 2nd century A.D.). To the north of the basilica the remains of a rectangular market are preserved ㊺. Later this market was replaced by a semicircular market with an Ionic colonnade.

On the east side of the Lechaion Road, north of the Fountain of Peirene ㊲, are preserved the foundations of Temple A ㊶, a Classical building that was converted in the Hellenistic period into a Heroon. The temple lies within and underneath the so-called Peribolos of Apollo ㊵ (1st century A.D.) This was an open courtyard surrounded by a marble Ionic colonnade, which was used as a market. At the northeast end of the street, the ruins of a large bathhouse dating to the late 1st century A.D. ㊷ have been identified as the Baths of the Spartan Eurykles, seen by Pausanias (2.3.5).

Corinth I.1 (1932), pp. 135–158; C. K. Williams II and J. E. Fisher, *Hesperia* 43 (1974), pp. 32–33.

㊲ FOUNTAIN OF PEIRENE

Move now to the eastern edge of the wooden platform for a view into the Fountain of Peirene, which is currently closed to visitors.

The Fountain of Peirene is an important center of symbolism and tradition in the urban landscape of both Greek and Roman Corinth (Figs. 94, 95).

Human activity is attested in the area from the Neolithic period, and the first efforts in water management date to the Geometric period. The facility was gradually embellished from the Archaic period onward, so that by the 2nd century B.C. it consisted of six chambers providing access to three deep draw basins. These were supplied with water from four huge reservoirs fed by conduits excavated hundreds of meters back under the Forum (Fig. 96).

The Fountain of Peirene probably suffered little in the attack on Corinth by the Roman general Mummius (146 B.C.), and was one of the first structures rebuilt. From the Early Roman period, the facade had engaged Doric half-columns between arches that framed the old antechambers (Fig. 95). The second story here was probably a solid wall with engaged Ionic half-columns. The sunken rectangle at

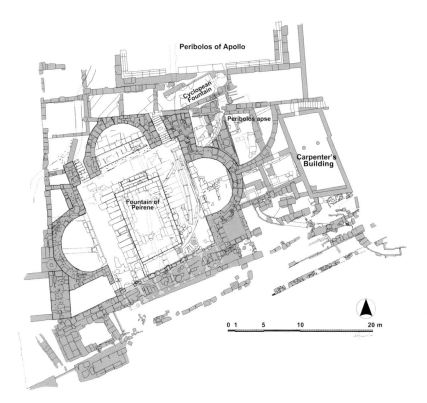

Figure 94. State plan of the Fountain of Peirene and nearby monuments

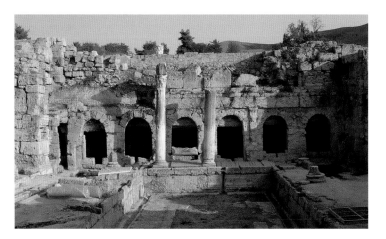

Figure 95. View of the facade of the Fountain of Peirene, from the north

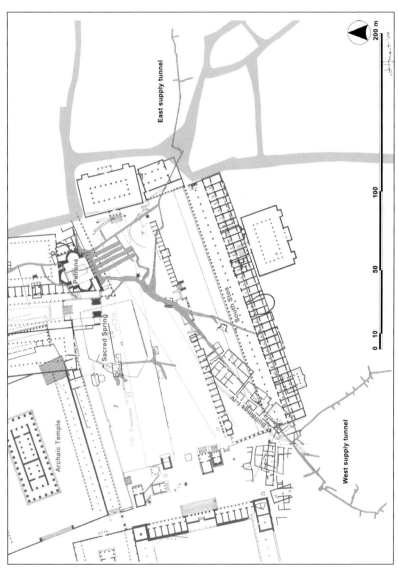

Figure 96. Plan of the water supply system of the Fountain of Peirene

the center of the courtyard in front of the facade is an open-air fountain accessed by a short broad stair. Waterspouts in the sides of the sunken area were served by large conduits running under the courtyard floor.

Figure 97. Sketch reconstruction of the out-looker screen on the facade of the Fountain of Peirene

Following the partial destruction of the earlier phase, perhaps by earthquake, the east and west apses were added in the 4th century A.D., and the reused marble columns and their decorative "outlookers" in the late 5th–early 6th century A.D. (Fig. 97). In later centuries, the ground level rose, and the court was occupied by a small chapel and cemetery (Fig. 98). Even after the fountain and courtyard were completely buried, the spring continued to provide water for the village fountains and numerous wells.

Myth records two origins for the spring. In one, Poseidon's lover, Peirene, literally dissolved into tears when Artemis accidentally killed her son, Kenchrias. The other myth attributes the spring's creation to the hoofprint of the winged horse Pegasos when he stamped in irritation after being bridled by Bellerophon.

Corinth I.6 (1964), pp. 1–115; Ancient Art and Architecture in Context 2 (2011).

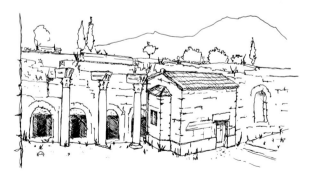

Figure 98. Sketch reconstruction of the Byzantine chapel in the court of the Fountain of Peirene

MONUMENTS NEAR THE FOUNTAIN OF PEIRENE

Descending from the steps at the start of the Lechaion Road **36**, turn to the right to move in front of the Fountain of Peirene **37**. Here one can walk along the northern apse of the fountain. This point provides another view into the fountain. Ahead, at a lower level than Peirene, is the so-called Cyclopean Fountain **38**. Above and to the right is Carpenter's Building **39**, while opposite are several standing marble Ionic columns of the Peribolos of Apollo **40**. To the right as one returns to the Lechaion Road are blocks from the epistyle of the Peribolos of Apollo set upon the stylobate of the colonnade. One block in particular stands out: on the front of the block (facing toward the north) is part of the dedicatory inscription for the Peribolos of Apollo (I-241), and on the back (facing toward the south) is a relief of a single rower in a ship encircled by a wreath, which probably represents a wealthy merchant and one of the dedicators of the colonnade. Behind this block are the foundations of Temple A **41**, partly under later shops along the Lechaion Road and partly under the Peribolos of Apollo.

38 CYCLOPEAN FOUNTAIN

Although separated from the Fountain of Peirene **37** today by later structures, the Cyclopean Fountain was always closely connected to Peirene and its water source (Fig. 99). Its earliest phase dates to the 6th century B.C. and it received its final form in the Hellenistic period,

Figure 99. Sketch reconstruction of the pre-Roman phase of the Fountain of Peirene (right) and the Cyclopean Fountain (left)

with a ramped approach. The fountain bears the modern nickname "cyclopean" because its masonry style is similar to that of the walls of Bronze Age citadels such as Tiryns and Mycenae, which Classical Greeks attributed to the giant Cyclopes—a term then adopted by modern scholars. The Cyclopean Fountain was designed to mimic a rustic cave spring.

Ancient Art and Architecture in Context 2 (2011), pp. 134–141, 156–158.

㊴ CARPENTER'S BUILDING

Named for Rhys Carpenter, the director of the ASCSA and of the Corinth Excavations from 1927 to 1931, this Byzantine house east of Peirene was in use from the 10th to the 12th century A.D. After its excavation in 1917, it was renovated with the addition of a second story and a pitched roof in order to store Byzantine sculpture found at Corinth (see Fig. 100). The building was finally abandoned during World War II, but it still stands as a witness to the interest of the excavators in the medieval history of the site.

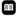

K. Kourelis, *Hesperia* 76 (2007), pp. 391–442.

㊵ PERIBOLOS OF APOLLO

The large colonnaded courtyard to the north of the Fountain of Peirene was identified by Pausanias (2.3.3) as the "Peribolos of Apollo," in which he saw an image of the god and a painting depicting Odysseus in the act of expelling the suitors of his wife, Penelope. The painting might appropriately relate to Peirene because, according to one tradition, Peirene was Penelope's aunt.

The rectangular court, built in the 1st century A.D., measures ca. 32 × 23 m and was surrounded by a marble Ionic colonnade set on a stylobate of Acrocorinth limestone (Fig. 100). The colonnade was unpaved until it received a mosaic floor in the 3rd century (Fig. 101). A dedicatory inscription indicates that a member of the tribe Aemilia was the benefactor.

Two earlier structures lie under the Peribolos of Apollo. The older of the two is a complex known as the dye works (Fig. 102). Established

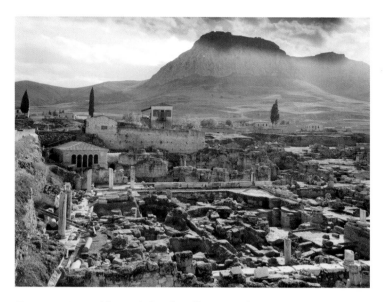

Figure 100. View of the Peribolos of Apollo in 1930, from the northeast, with Carpenter's Building in the middle ground to the left

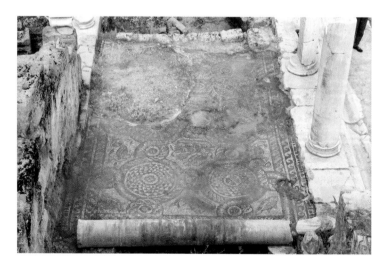

Figure 101. Mosaic floor in the southeast part of the Peribolos of Apollo in 1931. The elaborate mosaic of white, black, red, and yellow includes a triple border with bead-and-reel, wave, and guilloche patterns framing circular fields. The interstices contain fish and waterfowl.

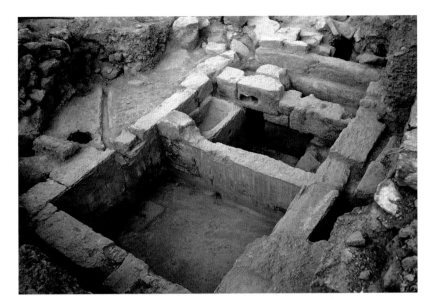

Figure 102. The reservoir of the dye works beneath the Peribolos of Apollo

ca. 550 B.C., the dye works included drying floors and a reservoir, added later, in the third quarter of the 5th century B.C. In addition to the architectural features, deposits of murex shells found in the complex led the excavator to identify the building as the site of a dye works. Murex shells were exploited in antiquity for the production of purple dye. The second structure beneath the Peribolos of Apollo is Temple A **④**, discussed below.

Corinth I.2 (1941), pp. 1–54; *Corinth* VIII.2 (1931), no. 124.

④ TEMPLE A

Temple A is a Classical and Hellenistic structure that lies partly under the shops along the east side of the Lechaion Road and partly under the Peribolos of Apollo **④**. Preserved are the foundations of a small *distyle-in-antis* temple of the 4th century B.C., which was converted in the 3rd century into an *aedicula*. The latter consisted of four square pillars supporting a pitched roof. The two western pillars were joined by a wall. The monument probably housed the image of a god or

Figure 103. Semicircular altar and pebble mosaic east of Temple A, from the north. To the right are the foundations of Temple A. Three of the four square bases that supported a roof over the altar are visible.

hero. A pebble mosaic leads from the *aedicula* to a semicircular altar (Fig. 103). The fact that the altar was also covered by a roof indicates that the sacrifices were intended not for an Olympian deity, but for a chthonic (underworld) deity or a hero.

Corinth I.2 (1941), pp. 4–16.

④② BATHS

On his way from the Forum north along the Lechaion Road, Pausanias (2.3.5) observed:

> *The Corinthians have baths in many parts of the city, some put up at the public charge and one by the emperor Hadrian. The most famous of them is near the Poseidon. It was made by the Spartan Eurycles, who beautified it with various kinds of stone, especially the one quarried at Croceae in Laconia.*
> (trans. W. H. S. Jones)

A large bath on the east side of the Lechaion Road, north of the Peribolos of Apollo, is one of two baths in Corinth that have been

identified as that of Eurykles. (The other is the Great Bath on the Lechaion Road 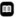.) The walls were covered with a revetment of different colored stones, including *lapis lacedaemonius*, a dark green porphyry with light green flecks, from the Eurykles family quarries at Krokeai in Lakonia. It is uncertain whether the Eurykles mentioned by Pausanias is Caius Julius Eurykles, who was a senator under the emperors Trajan (A.D. 98–117) and Hadrian (A.D. 117–138). An Early Imperial phase of the building was identified, but the extant remains date to the late 1st century A.D., after the earthquake of the A.D. 70s, with later renovations. It may have remained in use until the late 4th century. The building had an open courtyard with a pool, and on the east side, a sequence of bathing rooms, some heated (Fig. 104).

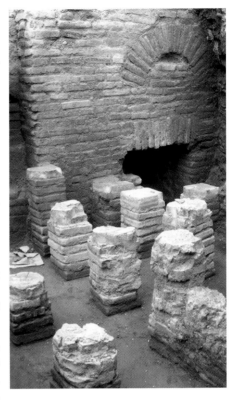

Figure 104. Hypocausts in the baths north of the Peribolos of Apollo in 1930

J. Biers in *Corinth* XX (2003), pp. 305–307; C. K. Williams II, *Hesperia* 38 (1969), pp. 62–63; C. K. Williams II, J. MacIntosh, and J. E. Fisher, *Hesperia* 43 (1974), pp. 25–33.

43 LATRINES

About halfway along the east side of the Lechaion Road are the remains of a public latrine, including seats and a water channel around the edge of the floor. In antiquity, a communal sponge on a stick would have been located in the channel for users of the latrine to cleanse themselves.

Corinth I.4 (1954), p. 152.

④④ LECHAION ROAD BASILICA
⚡ Turn now to the west side of the Lechaion Road.

The basilica flanking the west side of the Lechaion Road was built at the end of the 1st century B.C., after Corinth had become the capital of the Roman Province of Achaia. The structure was a large rectangular hall, ca. 70 m long × 25 m wide. The interior was arranged as an open hall with an interior colonnade to support a second-story gallery. At the north end were three rooms, with the central room probably serving as the tribunal. At the south end two rooms flanked the entrance hall. These rooms were all demolished when the basilica was enlarged and refurbished in marble in the mid-2nd century A.D. The new floor level was 0.5 m higher than before, and the interior had the appearance of a large hall with a colonnade on all four sides. The main approach to the basilica was through a court entered through the Captives' Facade ③④. Underlying the basilica is a stoa known as the North Building, which perhaps dates to the 5th century B.C.

Basilica: *Corinth* I.1 (1932), pp. 193–211, A. Ajootian, *Hesperia* 83 (2014), pp. 315–377. **North Building**: C. A. Pfaff in *Corinth* XX (2003), pp. 135–136.

④⑤ MARKETS ALONG THE LECHAION ROAD

On the west side of the Lechaion Road, north of the basilica ④④, stands a building long identified as a market. Although it has not been completely excavated, the plan is sufficiently clear, including a central court surrounded by a colonnade with rooms along three sides. Remains of a similar building, later partly destroyed by the construction of the Peribolos of Apollo ④⓪, were found on the east side of the road, north of the Fountain of Peirene ③⑦. Both of these structures were originally identified as markets because they produced fragments of inscriptions referring to a *macellum* (meat market) Ⓜ. The western structure has recently been reidentified as a group of offices rather than a market. At some point, possibly after an earthquake in the 70s A.D., a semicircular Ionic colonnade, nicknamed the Hemicycle, was constructed within the rectangular peristyle courtyard.

Occupying the same site several centuries earlier was a structure known as the Trader's Complex. Built in the last quarter of the 7th century B.C., this large house included at least three or four rectangular

rooms. It was covered by a deep clay fill sometime between 580 and 560 B.C. The complex takes its modern name from the pottery found within, which included *bucchero* (black glossy Etruscan pottery) as well as chalices from Chios and Rhodes. These finds show the geographic spread of the trading activities of the building's owner, from Italy in the west to the islands of the eastern Aegean.

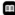

Marketplaces: *Corinth* VIII.2 (1931), nos. 124, 125. **Trader's Complex**: C. K. Williams II, J. MacIntosh, and J. E. Fisher, *Hesperia* 43 (1974), pp. 14–24.

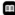 Leave the site by the steps up to the exit. Turn left, passing the Old Museum and the north side of Temple Hill on the way toward the Odeion **46** and Theater **47**. At the end of the village center is a children's playground, built partly on top of an artificial hill created out of excavation debris. Across the parking lot in front of the museum are the Odeion (on the south side of the road) and the Theater (on the north side of the road).

46 ODEION

The Roman Odeion of ancient Corinth was a small, indoor theater intended for musical events and rhetorical competitions (Fig. 105). It consisted of a semicircular orchestra surrounded by seating, a stage

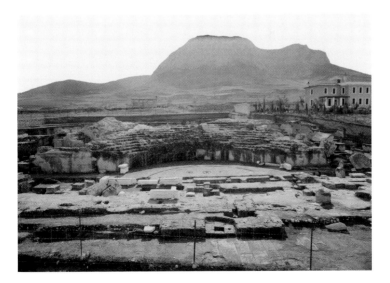

Figure 105. View of the Odeion in 1931, from the north

Figure 106. State plan of the Odeion

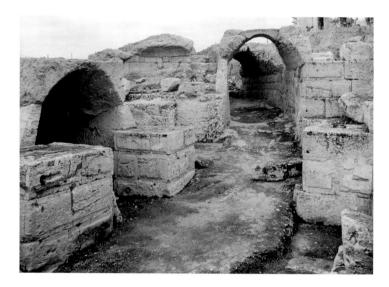

Figure 107. West end of the semicircular corridor surrounding the auditorium of the Odeion in 1931

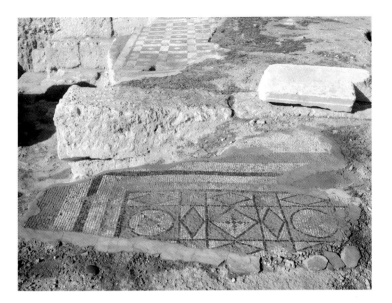

Figure 108. Mosaics from rooms at the west end of the Odeion court in 1931

building, and two roofed *parodoi,* or entryways (Figs. 106, 107). It is thought to have held an audience of about 3,000. Built in the 1st century A.D., it was remodeled in the mid-2nd century A.D., perhaps with money provided by the famous philanthropist Herodes Atticus. A courtyard surrounded by colonnades was constructed to the north of the stage building, connecting the Odeion with the Theater ㊼ and presenting the two buildings as a unified complex. A colossal statue of Athena Ⓜ found in the Odeion, together with the remains of mosaic floors (Fig. 108), give an indication of the impressive decoration of the building. The third building phase (ca. A.D. 225) followed a fire that destroyed the peristyle courtyard and part of the stage building. In this phase, the stage building fell into disuse and the Odeion was converted into a gladiatorial arena by cutting back the lowest eight rows of orchestra seating. The Odeion was finally destroyed at the end of the 4th century A.D., but the ruined structure continued to be used for private dwellings (Fig. 109).

Corinth X (1932).

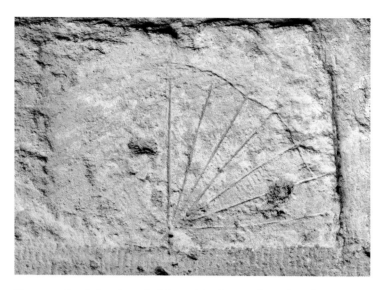

Figure 109. Sundial on the wall of the semicircular corridor in the Odeion in 1931. The sundial must date to a period when the ruined structure was used for private dwellings, since only then would the sun have shone on the wall of the corridor.

④⑦ THEATER

🅝 A steep, stepped footpath leads from the road down to the Theater.

The Theater was a place in which dramatic and musical events were staged (Fig. 110). The building has several phases. The original structure was built late in the 5th century B.C. and had permanent seats but only a wooden stage building. This was supplemented with a new orchestra and stage structure in the Hellenistic period. Early in the reign of the emperor Augustus the building was adapted to Roman tastes. In the early 1st century A.D., the pitch of the seats was made steeper, and the uppermost portion of the auditorium received a covered stoa. The stage building was rebuilt in the Hadrianic to Early Antonine period. It had a three-storied colonnaded facade with relief sculptures beneath the columns (Fig. 111). The sculptures included scenes of gods fighting giants, Greeks fighting Amazons, and the Labors of Herakles Ⓜ. Later in the Roman period theatrical tastes changed and the orchestra was converted into a gladiatorial arena. The lower seats of the orchestra were cut back to create a vertical face separating the audience from the combatants. This barrier once preserved

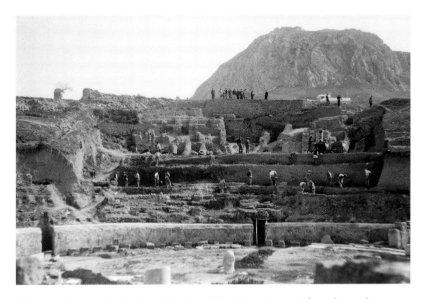

Figure 110. *Excavations in the auditorium of the Theater in 1926, from the north*

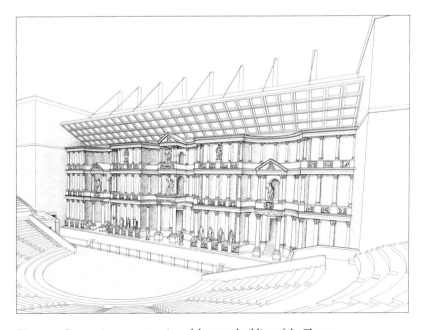

Figure 111. *Perspective reconstruction of the stage building of the Theater, Hadrianic period*

Figure 112. Josephine Platner Shear recording wall paintings once preserved on the barrier between the seats and the orchestra of the Theater in 1925

frescoes showing lions, a bull, a leopard, and men fighting animals (Fig. 112). A scratched inscription beneath one lion refers to the story of Androkles and the lion. The orchestra was later waterproofed to enable the staging of aquatic spectacles such as water ballets.

In the courtyard to the east of the stage building is an inscription reused in the floor, with cuttings designed to receive cast bronze letters. It reads "ERASTUS PRO AEDILITATE S P STRAVIT," which may be translated as "paved by Erastus at his own expense in return for his aedileship" (Fig. 113). A chamberlain (*oikonomos*) of Corinth

Figure 113. The Erastus inscription from the Theater in situ (I-2436), east of the stage

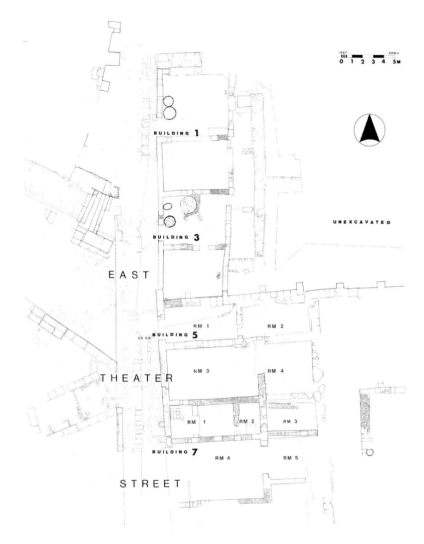

Figure 114. Plan of the excavations east of the Theater

named Erastus was mentioned by the apostle Paul in Romans 16:23, and many believe that the inscription refers to the same person.

In antiquity the main approach to the Theater from the Forum was along a north–south street known today as "East Theater Street." A series of buildings on the east side of this street was excavated in the 1980s (Fig. 114). Two of the buildings (Buildings 1 and 3) were food

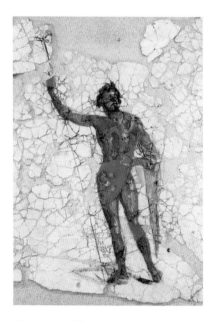

Figure 115. Wall painting from east of the Theater, depicting Zeus holding a scepter possibly crowned with an eagle

Figure 116. Wall painting from east of the Theater, depicting Aphrodite gazing at her reflection in Ares' shield

shops catering to theatergoers. The north room in each building contained a domed oven, and large quantities of animal bone were found in the south room of Building 3. They were built in the 1st century A.D. and destroyed by an earthquake sometime between A.D. 125 and 150.

Buildings 5 and 7, higher up to the south, were supported by a buttressed wall separating them from the caterers. These buildings were related to religious activity, including worship of the gods Aphrodite, Isis, Serapis, and Cybele; wall paintings from Building 5 are on display in the museum Ⓜ. The walls of Building 7, room 2 were also decorated with wall paintings: white panels framed by tall Corinthian columns, each containing a small figure of a deity, including Herakles, Hera, Zeus, Athena, and Aphrodite (Figs. 115, 116). Built in the 1st century A.D., Buildings 5 and 7 suffered the same fate as Buildings 1 and 3, but were refurbished and continued in use until they were destroyed by earthquake in the later 4th century A.D. The debris from this quake was cleared from the street, and it was open to traffic through the 5th century A.D.

East Theater Street and a broad *decumanus* (an east–west street) terminated at an open paved court east of the Theater's stage building, where the Erastus inscription is located.

A partially preserved brick building rising prominently above the fields north of the Theater can perhaps be identified as a bath, likely dating to after ca. A.D. 200. Slots visible in the walls of the building could have held water pipes to supply water to the bath.

Theater and its sculpture: *Corinth* II (1952); *Corinth* IX.2 (1977); *Corinth* IX.3 (2004). **Erastus inscription**: *Corinth* VIII.3 (1966), no. 232. **East of Theater excavations**: C. K. Williams II and O. Zervos, *Hesperia* 58 (1989), pp. 1–50. **Bath**: J. Biers in *Corinth* XX (2003), pp. 308–309.

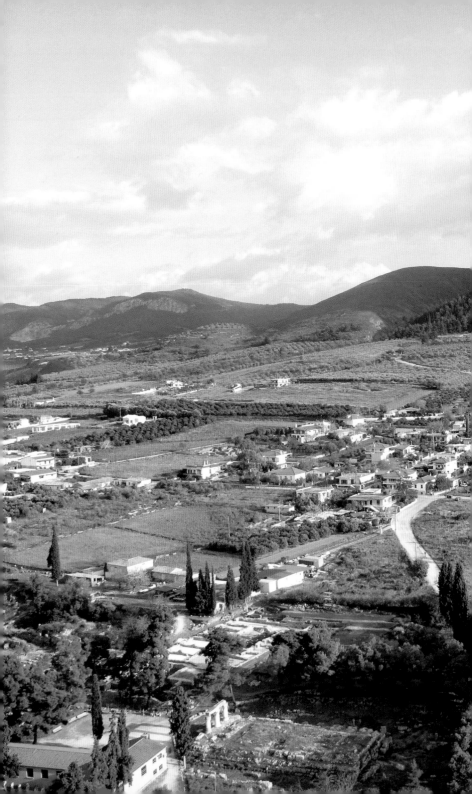

Site Tour:
Outside
the Forum

SOUTH OF THE FORUM

The area surrounding the village of Ancient Corinth is full of monuments from all time periods. Some are unprotected by fences, while others are locked behind gates. Visitors are invited to explore the landscape and its monuments and enjoy this sense of discovery. If visitors desire access to protected monuments, they should speak to the guards at the entrance to the site.

48 HADJI MUSTAFA

(700 m, 11 min.) From the site entrance, go southwest 75 m and immediately turn south 625 m. The fountain is visible at the base of Acrocorinth 50.

Hadji Mustafa is the popular name of a fountain at the base of Acrocorinth (Fig. 117). The fountain consists of a cistern for collecting water from a nearby spring and an arched facade built of limestone and reused marble elements. A three-line inscription in Arabic records the benefaction:

> *Joseph the Tailor ordered the construction of this for flowing*
> *water entirely at his own expense, for the love of God, let him*

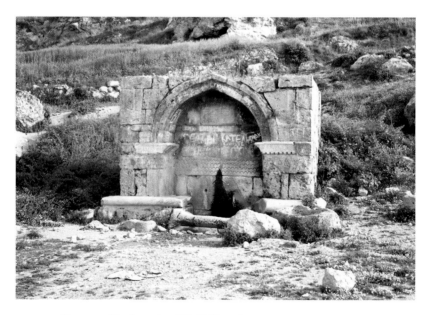

Figure 117. The fountain of Hadji Mustafa

be exalted, and desiring to please the merciful Lord, in the
nine hundred and twenty first year [of the Hejira (A.D. 1515)].
(trans. P. A. MacKay)

The water comes from a small-yield spring nearby, and is used daily
by residents of the modern village.

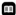

P. A. MacKay, *Hesperia* 36 (1967), pp. 193–195.

49 SANCTUARY OF DEMETER AND KORE

(1.7 km, 24 min.) From Hadji Mustafa 48, take one of the footpaths behind the
fountain for a strenuous but short 200 m hike due south, straight up the slope; or follow
the road southeast up Acrocorinth 50 for 1 km, switching back to the southwest, and
enter through a metal gate down the steps. The sanctuary is largely covered over.

Excavations on the north slope of Acrocorinth in the 1960s and 1970s
revealed a sanctuary dedicated to Demeter and Kore, the largest in
Greece after that of Eleusis (Fig. 118). An ancient road gives access
to a processional staircase, on either side of which are at least 40
dining halls, the earliest dating to the late 6th century B.C., the latest

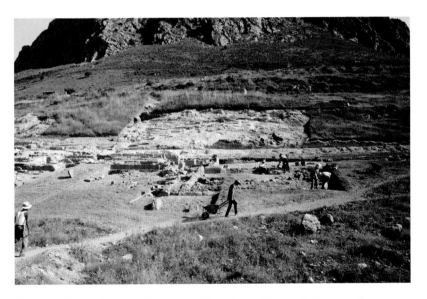

Figure 118. Excavation of the Sanctuary of Demeter and Kore with Acrocorinth
in the background

to the late 4th century B.C. (Figs. 119, 120). The cult center initially comprised a court with a small temple at one end, and an elevated terrace with a sacrificial altar to one side. Near the end of the 4th century B.C. the sanctuary was rebuilt. Access to the cult center was now controlled by a Doric propylon, the temple was moved up the hill, and a small theatral area was added for no more than 100 people. A stoa replaced the old temple, at the east end of which was a deep sacrificial pit. Tens of thousands of votive offerings have been found, some with inscribed dedications to the two goddesses, including pottery, figurines, large statues in terracotta (Fig. 121), jewelry, and loomweights for weaving. A selection of these votives is on display in the museum Ⓜ.

With the Roman colonization of Corinth, a new sanctuary was erected over the old in the 1st century A.D. (Fig. 122). The dining rooms and the stairway were covered over, the propylon enlarged, and three small Ionic temples were built, the central one of which has a mosaic floor with a geometric pattern and a panel depicting two

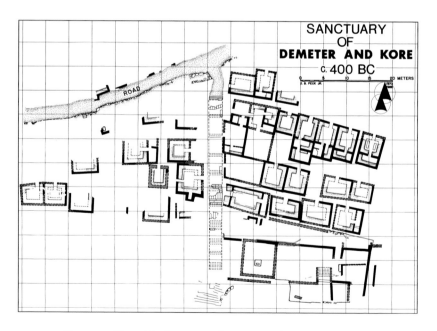

Figure 119. Plan of the Sanctuary of Demeter and Kore in 400 B.C.

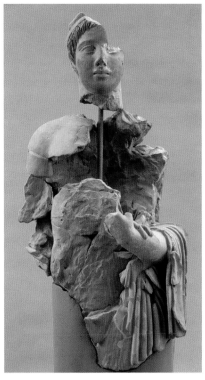

Figure 120. Dining room in the Sanctuary of Demeter and Kore, from the west

Figure 121. Large terracotta sculpture from the Sanctuary of Demeter and Kore

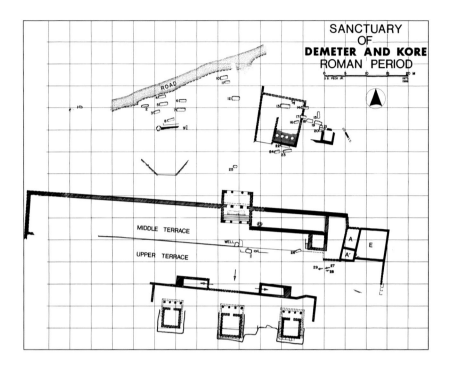

Figure 122. Plan of the Sanctuary of Demeter and Kore in the Roman period

baskets flanked by snakes on either side of a pair of feet (Figs. 123, 124). A mosaic text identifies the benefactor as the *neokoros* (temple official) Octavius Agathopous whose gift was made when "Chara was priestess of Neotera (Kore)." One of the dining halls below the propylon was turned into a new Roman cult building, in which curse tablets were dedicated. Worship at the sanctuary ended toward the end of the 4th century A.D.; in the 6th century A.D. the area was used as a cemetery.

Corinth Notes 2 (1987); *Corinth* XVIII.1 (1989); *Corinth* XVIII.2 (1990); *Corinth* XVIII.3 (1997); *Corinth* XVIII.4 (2000); *Corinth* XVIII.5 (2010); *Corinth* XVIII.6 (2013); *Corinth* XVIII.7 (2015).

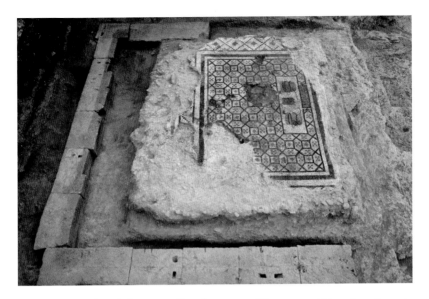

Figure 123. Temple with the mosaic floor, Sanctuary of Demeter and Kore, from the east

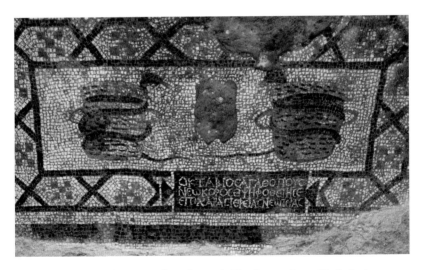

Figure 124. Detail of the mosaic, from the north. The decorated panel includes two wicker baskets, each with a snake wrapped around it, flanking the impression of two closely set feet. The inscription records the name of the mosaic's donor, a temple official named Octavius Agathopous.

🔟 ACROCORINTH

 (3.6 km to the parking lot at the gates, a strenuous 50-minute hike or a quick drive) From Hadji Mustafa 🔢, take the road southeast, switching back to southwest and wrapping around the west side of the mountain to the parking lot and the gates of the castle. The path through the three gates is a short, steep ascent. The peak is an additional 45-minute hike from the parking lot, but more time is needed to explore.

Acrocorinth (575 m; Fig. 125) was described by the Macedonian king Philip V as one of the "fetters of Greece" (Polyb. 18.11). It controlled not only the route across the Isthmus, but also the pass between the Isthmus and Mount Oneion leading south toward Kleonai and Argos, and the coastal road west to Sikyon. Although the oldest fortifications may be prehistoric, the earliest datable walls belong to the 4th century B.C. (Fig. 126). These were breached by Demetrios Poliorketes in 303 B.C. and later reduced and rendered indefensible by the Roman general Mummius in 146 B.C. The present fortifications largely represent work and rework of the Byzantine, Ottoman, Venetian, and Early Modern periods. Within the walls are the remains of the Ottoman settlement

Figure 125. The three west gates of Acrocorinth in 1932. The outermost gate is Ottoman, the second gate is Venetian, and the inner gate is partly of the 4th century B.C.

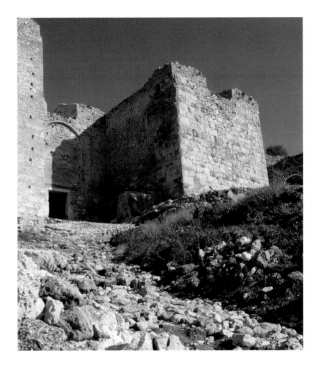

Figure 126. The inner gate of Acrocorinth

described by various travelers, including Evliya Celebi in 1668 and Wheler and Spon in 1676. They include the remains of mosques, fountains, and houses (Fig. 127). Next to the Upper Fountain of Peirene is a Venetian building used as barracks for King Otto's Bavarian garrison.

The earliest known antiquary to have studied Acrocorinth was Cyriacus of Ancona who, in 1436, transcribed several of the inscriptions on the walls of the Upper Fountain of Peirene. The American School made trial trenches on the summit in 1896 and exposed part of an ancient quarry. In 1926 the School excavated on the summit, hoping to find remains of the Temple of Aphrodite described by Pausanias (2.5.1). The director, Carl Blegen, employed a team of veterans from Mycenae who had worked with him at Zygouries, Nemea, Phlius, and the Argive Heraion. Their number varied from 16 to 51 men, and they lodged in the mosque below the summit (Fig. 128). The American staff stayed in the village and made the stiff climb up to the excavation every day. They found part of a Mycenaean figurine

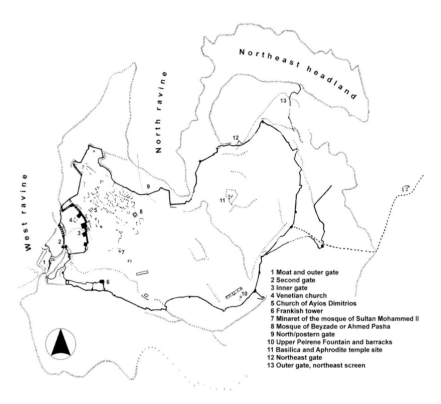

1 Moat and outer gate
2 Second gate
3 Inner gate
4 Venetian church
5 Church of Ayios Dimitrios
6 Frankish tower
7 Minaret of the mosque of Sultan Mohammed II
8 Mosque of Beyzade or Ahmed Pasha
9 North/postern gate
10 Upper Peirene Fountain and barracks
11 Basilica and Aphrodite temple site
12 Northeast gate
13 Outer gate, northeast screen

Figure 127. Plan of Acrocorinth

and Submycenaean/Protogeometric pottery close to bedrock. They
dated the stub of a wall by associated Protocorinthian and Corin-
thian pottery. Hellenistic fragments believed to be from the Temple of
Aphrodite were found reused in the walls of a small 7th-century A.D.
basilica, a medieval tower, and a small *tekke*, which successively occu-
pied the summit. Blegen also investigated the Upper Fountain of Pei-
rene. His team made plans, sections, and elevations of the architecture
and tunnels and fully documented the inscriptions first noted by Cyri-
acus five centuries earlier.

Corinth III.1 (1930); *Corinth* III.2 (1936).

Figure 128. View from Acrocorinth to the north in 1932. In the middle ground is the mosque of Beyzade or Ahmed Pasha.

TIMELINE FOR ACROCORINTH FROM THE HELLENISTIC PERIOD TO THE 19TH CENTURY	
303 B.C.	Demetrios Poliorketes ("the Besieger") takes Acrocorinth from the Macedonian king Kassandros
243 B.C.	Aratos of Sikyon takes Acrocorinth from Antigonos Gonatas
224 B.C.	Aratos relinquishes control to the Macedonian king Antigonos III Doson
146 B.C.	The Roman general Lucius Mummius reduces Corinth's fortifications
A.D. 1210	Acrocorinth is captured by Geoffrey de Villehardouin, a French knight who participated in the Fourth Crusade and later became Prince of Achaia, after a five-year siege
A.D. 1358	Acrocorinth is bestowed on Nicolo Acciaioli, a member of the Florentine banking family
A.D. 1394	Acrocorinth is in the hands of Theodoros I Palaiologos, Despot of Mistra
A.D. 1395	Nicolai de Marthono, a traveler to the Holy Land, observes only a few of the small houses occupied (50 families)
A.D. 1400–1404	The Knights of St. John repair the walls
A.D. 1458	Sultan Mehmed the Conqueror takes Acrocorinth
A.D. 1612	Acrocorinth is briefly held by the Knights of Malta
A.D. 1687	The Venetians enter Corinth without resistance
A.D. 1715	Corinth is recaptured by the Ottomans
A.D. 1821	Acrocorinth is taken by Christian Arvanites from the Megarid. Kjamil Bey of Corinth is held and later killed there.
A.D. 1822, January	Acrocorinth is taken by General Theodoros Kolokotronis
A.D. 1822, July	Acrocorinth is briefly held by the forces of Mahmud Dramali Pasha, governor of Larissa, Drama, and the Morea

WEST OF THE FORUM

⑤ ANAPLOGA

(Locked; 850 m, 11 min.) The site of the Roman villa (neither accessible nor visible) is located ca. 600 m southwest of the main site entrance, on the north side of the modern road past the turn-off to Acrocorinth. Another 250 m farther, sarcophagi from the cemetery are visible inside a fenced property on the north side of the road.

Anaploga was the old name of the hamlet 1 km southwest of the main archaeological site. The place is known today as Ayioi Anargyroi. ASCSA director Henry Robinson undertook several small-scale excavations in the vicinity during the early 1960s. One of these exposed a Roman villa with ornate mosaic floors Ⓜ, dating from the end of the 2nd century to the early 3rd century A.D. (Fig. 129). Another excavation revealed a small cemetery and an inspection manhole that opened onto over 700 m of underground water channels. One of the wells excavated contained a large quantity of Early, Middle, and Late Corinthian pottery (early 7th–mid-6th century B.C.), much of it restorable.

📖

S. G. Miller, *Hesperia* 41 (1972), pp. 332–354; *Corinth* VII.2 (1975).

㊿ POTTERS' QUARTER

(700 m, 25 min.) From the modern church of Ayioi Anargyroi in the hamlet of the same name (1 km southwest of the site entrance), walk southwest, and after 100 m cross a ravine. Continue on the asphalt road west for 100 m to a fork in the path. Take the fork to the northwest, and after 300 m you will arrive at the edge of a ravine. Continue north through the groves for 200 m to the site, which extends north along the edge of the ravine.

Located at the western edge of the Greek city walls of Corinth, the Potters' Quarter was a complex of workshops and domestic buildings used by potters for three centuries, from the 7th to the 4th century B.C. (Figs. 130, 131). Large quantities of pottery produced here were shipped from Corinth to the western Mediterranean. Excavations produced wasters of pottery made from the white marl clay underlying the limestone bedrock Ⓜ. Molds indicate that the potters also made figurines, painted plaques, and votive shields (Fig. 132) Ⓜ. Excavators also found six *stele* shrines (Fig. 133) Ⓜ.

📖

Corinth XV.1 (1948); *Corinth* XV.2 (1952); *Corinth* XV.3 (1984).

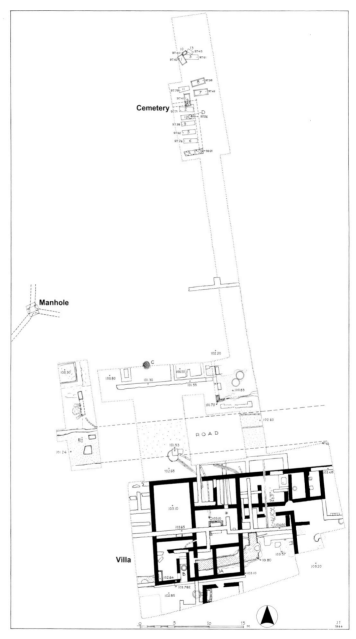

Figure 129. Plan of the Anaploga area

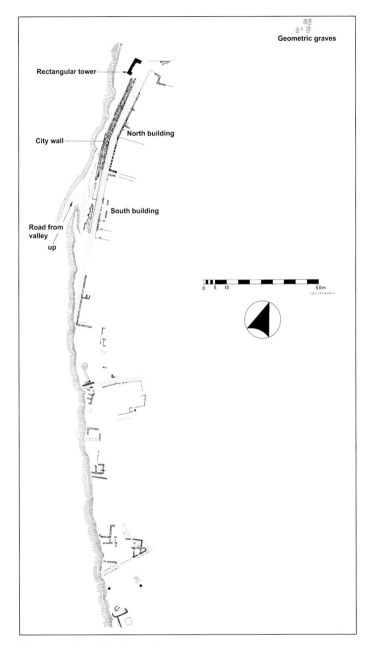

Geometric graves

Rectangular tower

North building

City wall

South building

Road from
valley
up

0 5 10 50 m

Figure 130. Plan of the Potters' Quarter

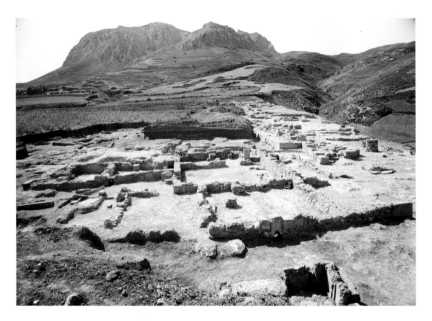

Figure 131. View of the Potters' Quarter in 1931

Figure 132. Terracotta figurines from the Potters' Quarter, ca. 6th century B.C.

Figure 133. A stele from the Potters' Quarter, broken and mended in antiquity

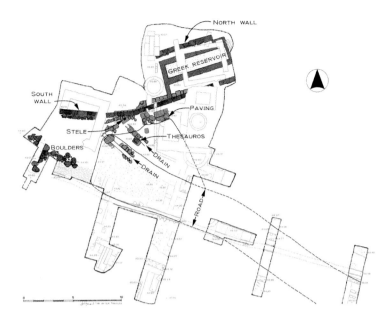

Figure 134. State plan of Kokkinovrysi in the Classical period, showing the location of the stele *shrine*

🔵53 KOKKINOVRYSI / SHEAR VILLA

🚶 (1.3 km, 15 min.) Go west from the site entrance 1.3 km via the road between the Odeion and the Theater. Before the road switches back one will see the modern stone structures that cover the remains.

Kokkinovrysi (Red Spring) is located west of Cheliotomylos 🔵54, along the lower terrace at the northern edge of the ancient city. The spring is located next to an ancient road, west of the line of the city wall. In 1962 and 1963 a rescue excavation here uncovered a small sanctuary with a *stele* shrine (Fig. 134). In a pit next to the limestone *stele* were found numerous terracotta figurines representing a ring dance around a central figure playing the flute (Fig. 135) Ⓜ. The shrine was probably dedicated to the nymphs, and its history of use ran from at least the 7th until the late 4th century B.C.

To the east of the spring are the remains of a potters' kiln, and to the west is the so-called Shear Villa. This Roman villa was excavated in 1925 by T. L. Shear and contained fine mosaics. One depicts a herdsman playing his flute in the shade of a tree as his cattle graze at the foot of a hill Ⓜ; in another is a circular panel with the head of Dionysos Ⓜ.

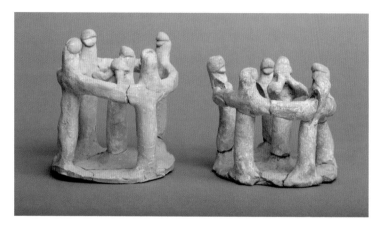

Figure 135. Terracotta figurines of dancing groups from Kokkinovrysi

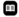

Kokkinovrysi: H. S. Robinson, *The Urban Development of Ancient Corinth* (Athens, 1965), pp. 77–78; C. K. Williams II, *Hesperia* 50 (1981), pp. 409–410. **Shear Villa**: *Corinth* V (1930).

54 CHELIOTOMYLOS

(1 km, 12 min.) From the site entrance, head west via the road between the Odeion and the Theater for 200 m, turn north on the unpaved road west of the Theater downhill past the soccer field for 250 m to a paved road, then west again for 450 m to a dirt road on the right. About 100 m along this track turn right and cross the modern concrete irrigation channel to the hill of Cheliotomylos.

Cheliotomylos is a low hill located half a mile northwest of the Temple of Apollo ❹. Surface pottery and a prehistoric wall suggest that the hill was inhabited continuously from Early Helladic to Late Helladic periods. In 1930 Late Helladic I to IIIC sherds were found in the fill of Roman graves excavated in trenches on the lowest terrace of the northern side of the hill, as well as an Early Helladic well containing skeletal remains. Material from the well is exhibited in the Prehistoric Room of the museum Ⓜ. At the foot of the hill to the northwest between the road and the railway line, a Mycenaean tholos tomb was excavated in February 2007. For the importance of the discovery of the tomb in Corinth, see p. 177.

Part of a Mycenaean road dating to the Late Helladic IIIA2 period (second half of the 14th century B.C.) was excavated in 1966 by the Greek Archaeological Service during the construction of the National

Highway from Corinth to Patras. The excavated portion of the road was south of the modern highway, 5.58 km west of the center of New Corinth.

Apart from the prehistoric remains, Classical and Roman tombs were found here as well. Among the finds are a 4th-century B.C. funerary bed and a series of Roman tomb paintings Ⓜ.

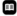

F. O. Waagé, *Hesperia* Suppl. 8 (1949), pp. 415–422.

 From Cheliotomylos hill, a cluster of cypress trees visible 1 km to the northeast marks the spot of the North Cemetery excavations ⑥⑥.

⑤⑤ NORTH TERRACE TOMBS

🔀 (1 km, 13 min.) From Cheliotomylos, follow the line of the modern irrigation channel east. The remains of the Roman chamber tombs are visible cut back into the edge of the terrace.

Several Roman chamber tombs were excavated in the 1930s along the edge of the terrace east of Cheliotomylos hill. In the 1960s, more tombs were found along the line of the modern irrigation channel built to carry water from Lake Stymphalos to the Isthmus of Corinth. The

Figure 136. Wall painting from the Painted Tomb

latter group included seven chamber tombs and 70 individual graves, most of which are located further east, near the Tile Works ⑥⓪. Their dates range from the late 1st century B.C. to the 6th century A.D.

One of the tombs, located immediately east of Cheliotomylos, has been nicknamed the Painted Tomb. It consisted of an antechamber leading to a burial chamber, each with multiple arched openings in which to place the bodies of the deceased, and wall paintings (on display in the museum Ⓜ) depicting men engaged in fishing and other rustic activities (Fig. 136).

Corinth XXI (2017).

NORTH OF THE FORUM

🔢 GYMNASIUM AREA

🅽 (Locked; 600 m, 7 min.) From the site exit, head north for 180 m, then turn west at the stop sign and continue for another 220 m. Turn right (northwest) and follow the dirt road for 170 m. Separate fenced areas are located on both sides of the road. The eastern fenced area has been united with the area of the Asklepieion 🔢, which cannot be accessed from here, to the northeast.

The Gymnasium mentioned by Pausanias (2.4.5) is thought to lie at the northern edge of the city, where several inscriptions dealing with athletes and athletics have been found. These inscriptions commemorate athletic events at Corinth and in the Isthmian Games during the reigns of Tiberius (A.D. 14–37) and Nero (A.D. 54–68). Excavations during the 1960s and 1970s to the south of the Asklepieion revealed part of an Early Imperial L-shaped stoa that is believed by some to be part of the gymnasium (Fig. 137). Others believe that it is part of a colonnade surrounding a large Doric temple, perhaps dedicated to Zeus.

A line of blocks here and across the road from the fenced area with the remains of the stoa includes a large Doric column drum and a piece of a Doric epistyle. The dimensions of these fragments indicate that the temple from which they came may have been the largest in the Peloponnese, although its location is unknown (Fig. 138). The blocks were reused in a segment of the Late Roman city wall, which for this reason is known as the Epistyle Wall. The Late Roman wall also included other reused Doric and Ionic column drums and inscriptions, together with other poros blocks. South of the stoa are the concrete foundations of the so-called Domed Building, which probably had an industrial function.

FOUNTAIN OF THE LAMPS Farther along the dirt road from the Gymnasium, on the right, is a bath-and-fountain complex built in a natural valley artificially enlarged in antiquity. In its earliest phase the supply of spring water was enhanced by tunneling horizontally into the plateau to trap other ground water, in order to supply a Classical bathhouse (Fig. 139).

In the Roman period the area in front of the bath was enlarged to create a court resembling that of the Fountain of Peirene 🔢. The rectangular walled area, oriented northeast to southwest, has a broad apse on its northeast side. It contains a large pool with a central plinth

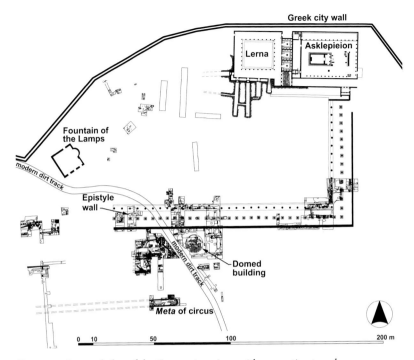

Figure 137. Restored plan of the Gymnasium Area with excavation trenches indicated

Figure 138. Blocks from a large Doric temple reused in a segment of the Late Roman city wall

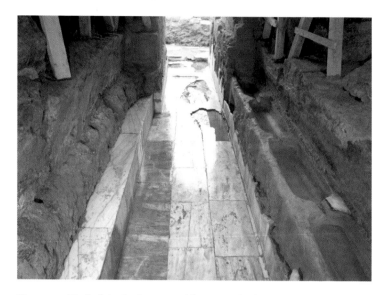

Figure 139. The bath in the Fountain of the Lamps, looking toward the entrance at the north. The washbasins along the east wall belong to the original phase (4th or 3rd century B.C.), while the marble paving on the floor and the bench opposite the basins date to a remodeling of the room in the Early Imperial period.

and steps at two of the corners (Fig. 140). On the southeast side are a series of three chambers: a bathing room, a nymphaeum, and a reservoir. The main chamber, the bathing room, contained thousands of votive terracotta lamps dating to the 5th and 6th centuries A.D., which gave the fountain its modern name.

CIRCUS A long, narrow structure with an apsidal end south of the Gymnasium has been identified as part of the *spina* of a Roman circus, a building for equestrian shows and competitions, or perhaps of a stadium for foot races (Fig. 141). A truncated marble cone Ⓜ found next to the apsidal end of the structure has recently been identified as the eastern *meta* (turning post) of the circus.

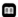

General: W. B. Dinsmoor, *Hesperia* Suppl. 8 (1949), pp. 104–115; J. Wiseman, *Hesperia* 41 (1972), pp. 1–42. **Fountain of the Lamps**: J. Wiseman, *Hesperia* 41 (1972), pp. 1–42. **Circus**: J. Wiseman, *Hesperia* 38 (1969), pp. 69–72; D. G. Romano, *Hesperia* 74 (2005), pp. 585–611.

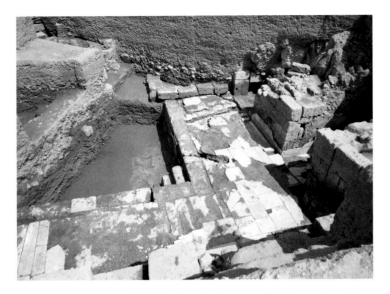

Figure 140. The courtyard of the bath in the Fountain of the Lamps, from the west

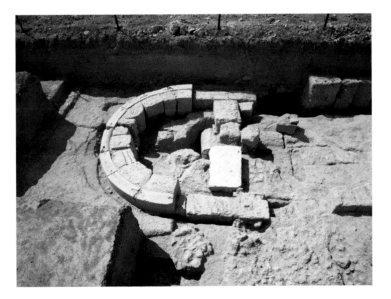

Figure 141. Apsidal structure identified as the eastern end of the spina of the Roman circus, from the north

57 ASKLEPIEION AND LERNA

⚷ (Locked; 600 m, 7 min.) From the site exit, head north for 180 m, then turn east at the stop sign and continue for another 90 m. Turn left (northwest) and follow the road for 350 m. The sanctuary is on the left as the road descends. The temple and upper sanctuary are visible from the locked gate.

The sanctuary of Asklepios is located in what was probably considered a healthy location on the north side of the city, close to a supply of fresh spring water. The precinct includes two levels: a higher *temenos* containing the temple to the east, and a courtyard with dining rooms and reservoirs, traditionally identified as the spring of Lerna (Paus. 2.4.5), to the west (Fig. 142). Within the *temenos*, the temple is represented by foundation trenches cut into the limestone bedrock, as well as several architectural blocks, including a portion of the temple's ramp and its entablature (Fig. 143). The earliest remains, perhaps of the 6th century B.C., are represented by shallow cuttings within, and to the northeast of, the later temple. The 4th-century B.C. temple stood in the middle of a rectangular enclosure and can be reconstructed as

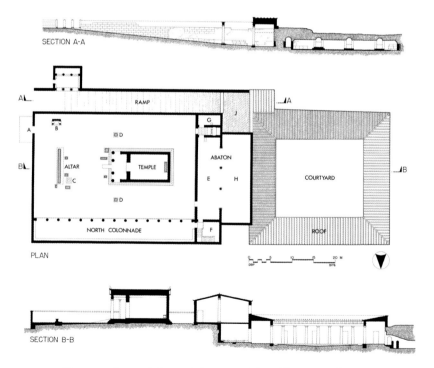

Figure 142. Restored plan and elevations of the Asklepieion and Lerna courtyard

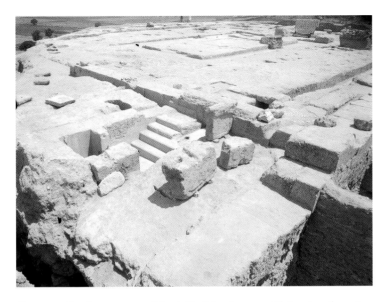

Figure 143. Southwest corner of the Asklepieion in 1931, with the steps down to the plunge bath at the center of the photograph

a rectangular *cella* faced with four Doric columns accessed by a short ramp up from the east, which is still visible today (Figs. 142, 144). On the north side there is a stoa, while various small cuttings might have been used for posts to display the life-sized terracotta body parts found during excavation Ⓜ. Doors on the west side entered into the *abaton*, where those in hope of a cure stayed, and to a space with steps descending to a plunge bath. A staircase at the north end of the *abaton* descends to the Lerna

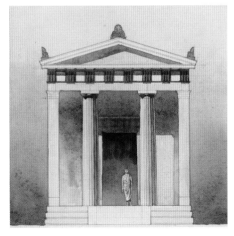

Figure 144. Restored elevation of the facade of the temple of Asklepios

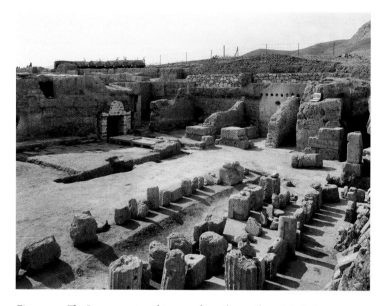

Figure 145. The Lerna courtyard in 1932, from the northwest. A dining room with two couches is visible at the upper left.

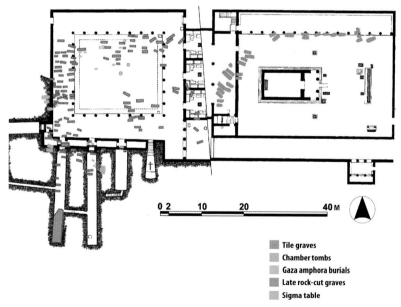

0 2 10 20 40 M

Tile graves
Chamber tombs
Gaza amphora burials
Late rock-cut graves
Sigma table

Figure 146. Late Roman graves found in the Asklepieion and Lerna courtyard

courtyard. After the foundation of the Roman colony, the temple was refurbished by Marcus Antonius Milesius, son of Glaucus, a freedman or son of a freedman of Marc Antony.

The main approach to the Lerna courtyard was by a steep ramp down past a springhouse southeast of the sanctuary (Fig. 142). The court consists of a central rectangular space surrounded by colonnades on four sides. On the east side of the court was a suite of three dining rooms beneath the *abaton* of the Asklepieion (Figs. 145, 146). Each room contained 7 tables set before 11 stone couches, three along each wall and two on either side of the door. The entrance to each room was offset toward the south, in order to accommodate the couches next to the door.

On the south side of the court are a springhouse and four long reservoirs fed by water channels dug back beneath the terrace to the south. The court fell into disuse during the Roman period, and it gradually filled with earth. In the 6th and 7th centuries A.D. the court and reservoirs were used for Christian burials (Fig. 146) and the springhouse was converted into a small chapel; gravestones from the cemetery are on display in the museum Ⓜ. Later, a church was built at the bottom of the ramp.

Corinth XIV (1951); *Corinth Notes* 1 (1977).

🔢 GREAT BATH ON THE LECHAION ROAD

🅽 (Locked; 150 m, 2 min.) From the site exit, pass through the village square heading northeast for 100 m, then turn north for 50 m. The bath is on the left.

North of the modern village square lie the remains of a large bath building, constructed ca. A.D. 200 (Figs. 147, 148). It has sometimes been identified as the bath built by Eurykles of Sparta, mentioned by Pausanias (see p. 114). In antiquity, it was approached through a portico entered from the east side of the Lechaion Road. A marble facade faced the visitor across a tiled courtyard. The restored drawing (Fig. 149) is based on the blocks from this facade, which were preserved in the debris from the earthquake that put the building out of use in the late 6th century A.D.

Corinth XVII (1985); J. Biers in *Corinth* XX (2003), pp. 308–314.

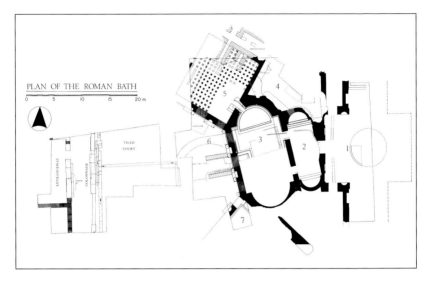

Figure 147. Plan of the Great Bath on the Lechaion Road

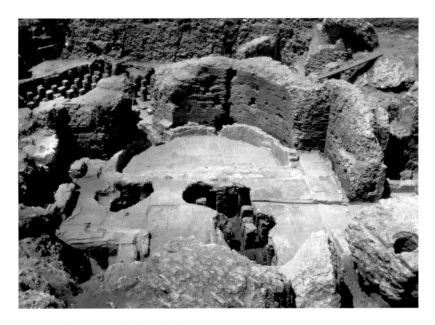

Figure 148. The Great Bath on the Lechaion Road, rooms 3 and 5, from the south. The hypocaust beneath the floor is visible in both rooms.

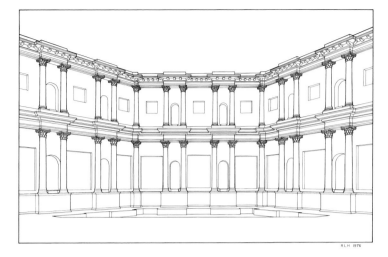

Figure 149. Perspective reconstruction of the marble facade of the Great Bath on the Lechaion Road

59 BATHS OF APHRODITE

(650 m, 8 min.) From the site exit, pass through the village square heading northeast for 100 m, then turn north, passing the Great Bath on the Lechaion Road 58 . Continue along the road and straight through the crossroads. After 240 m turn right, then immediately left, past the "Bath of Kjamil Bey" and down the winding road to the bottom. Thirty meters west of the road junction is a dirt path leading south into a fold in the escarpment. On the left is a monumental stairway leading down from the terrace above; the spring is at the head of the valley.

The "Baths of Aphrodite" was the name given, from the 19th century onward, to a spring and cave in the former pleasure garden of the Ottoman Bey's palace. It is located due north of the Forum on the line of the Lechaion Road and is at the head of a deep indentation of the high natural terrace (Fig. 150). The garden embraced the entire indentation and was connected with the terrace above by a monumental staircase (Fig. 151). The torus molding of the stair's outer wall suggests that it was built during the period of Venetian rule (1687–1715), when the Governor's residence stood at the site later occupied by the Bey's palace.

H. S. Robinson, *Hesperia* 31 (1962), pp. 120–130.

Figure 150. Plan of the Baths of Aphrodite and environs

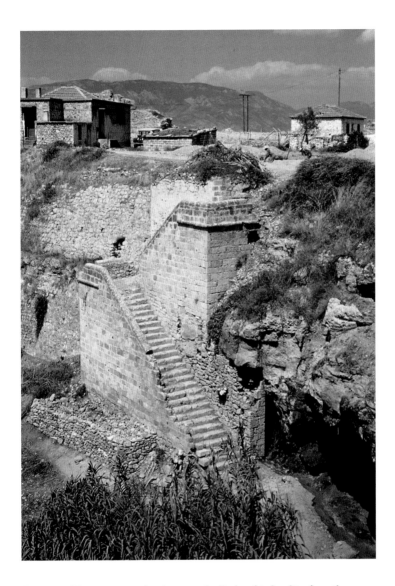

Figure 151. The monumental staircase at the Baths of Aphrodite, from the southwest

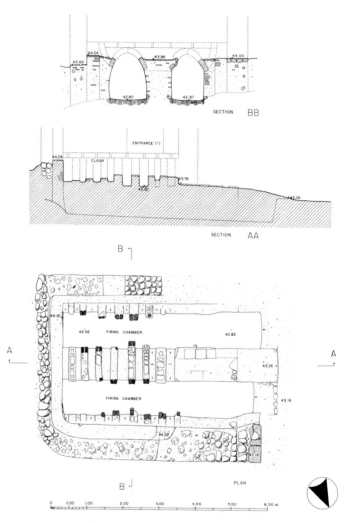

Figure 152. Plan and sections of the kiln at the Tile Works

60 TILE WORKS

(Locked; 1.2 km, 15 min.) Leave the village, heading northeast past the cemetery church of Ayia Anna. At the crossroad, follow the main road east toward the junction with the Corinth–Patras Highway. Next to a high rubble retaining wall, the road turns north passing under the irrigation channel to a stop sign. To the left, across the road in the olive grove, is a modern shelter built over the kiln. Much of it is easily visible through the windows and door of the structure.

To the north of the junction of the road leading to the village from the Argos road is a shed covering a well-preserved tile kiln. The kiln consists of two long firing chambers over which was once built the stacking chamber of the kiln (Fig. 152). Heat from the furnace was conducted into the stacking chamber through perforations in the floor. Surrounding the kiln were found wells, vats, and drying floors for washing, processing, and preparing the clay. The Late Archaic and Classical finds indicate that pottery, terracotta figurines, and perhaps also large-scale terracotta sculpture were produced here, in addition to roof tiles, antefixes, and ridge palmettes.

A series of Roman tombs was found along the irrigation channel to the south and east of the Tile Works (see 55).

G. S. Merker, *Hesperia* Suppl. 35 (2006).

61 BASILICA OF AYIOS KODRATOS

N (Locked; 1 km, 13 min.) Leave the village heading northeast past the cemetery church of Ayia Anna. At the crossroad, where the main road turns east toward the junction with the Corinth–Patras Highway, continue north on a dirt road for 200 m. The basilica is on the left.

The 6th-century A.D. Basilica of Ayios Kodratos is a three-aisled building without atrium or baptistery (Fig. 153). It is a cemetery church with mausolea attached to the aisles and graves within the aisles and nave. Among those buried here is an early bishop of Corinth named Eustathios.

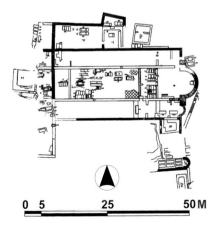

Figure 153. Plan of the Basilica of Ayios Kodratos

EAST OF THE FORUM

⑥ PANAYIA FIELD

🚻 (Locked; 450 m, 6 min.) From the site exit, head south out of the village square. The road winds east, then south, then west, then south again around the archaeological site. The Panayia Field is on the left side of the road immediately past the village school and basketball court.

The Panayia Field, southeast of the Forum, was the site of excavations between 1995 and 2007 (Fig. 154). The Roman remains are the best preserved, and in the process of their construction earlier building phases were cut back to the level of their foundations. Geometric, Archaic, Classical, Hellenistic, and earlier Roman levels are represented only by features such as graves, pits, foundations, cisterns, and cellars, which were cut into the pebbly red bedrock.

GEOMETRIC GRAVES The earliest remains found at the site were five Geometric graves. The two southernmost graves contained monolithic sandstone sarcophagi, each weighing in excess of two tons (Fig. 155). They had been shaped using an adze. Typologically

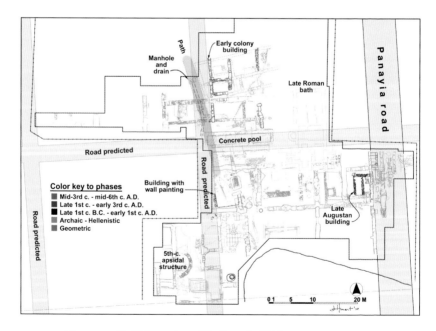

Figure 154. Multiphase plan of the Panayia Field

Figure 155. Two Geometric sarcophagi in the Panayia Field

distinct vessels used in the burial ritual (perhaps for holding wine, water, and oil) and found in the two graves suggest a date of the first quarter of the 9th century B.C. (Fig. 156). The sarcophagi clearly show that technological advances in the extraction, shaping, and transportation of heavy stone blocks at Corinth took place about 200 years earlier than once thought. One grave of the later 9th century B.C. contained the earliest oolitic limestone sarcophagus at Corinth. The grave may have been marked by a simple faceted column found embedded in a Roman wall built over the burial.

Figure 156. Niche in the side of a Geometric grave in the Panayia Field, containing 14 complete vessels and an iron spearhead

ARCHAIC TO HELLENISTIC PERIOD To the east of the Geometric graves were several shallow deposits and a large rectangular pit. These contained fragments of miniature vessels as well as wine jugs, drinking cups, cosmetic boxes, and terracotta figurines. The material suggests that the location of the graves was known, and that activity connected with the commemoration of ancestors began in the Archaic period and continued into the Hellenistic period. The most substantial Hellenistic remains—found on the east side of the excavated area, in the vicinity of the Roman road, and to the north of the Geometric graves—consist chiefly of cisterns and cellars dug below floor level. Large quantities of Hellenistic pottery were dumped into these features when they went out of use.

PANAYIA DOMUS Fourteen rooms of a large Late Roman *domus* (townhouse) include two with intricate geometric mosaic floors and one with a central marble fountain (Figs. 157, 158). One of the two peristyle courts within the building featured a stream running inside the colonnade; another room contained a long concrete pool.

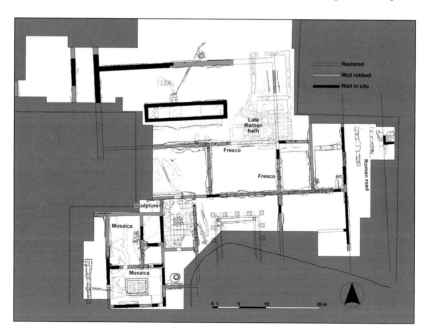

Figure 157. Plan of the Panayia Domus

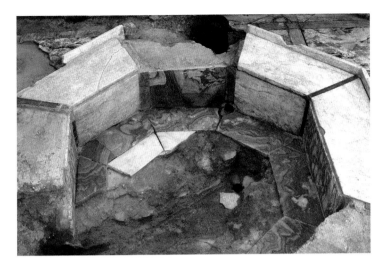

Figure 158. Octagonal fountain in the Panayia Domus

Figure 159. Wall painting of Nike from the Panayia Domus

The house was decorated with wall paintings (Fig. 159), and one small room contained a cache of small-scale sculpture, including representations of Roma and Asklepios (Figs. 160, 161) Ⓜ.

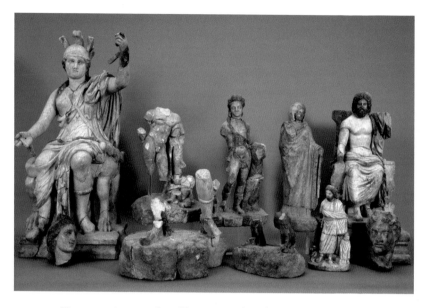

Figure 160. A group of marble statuettes found together in a small room in the Panayia Domus, likely a domestic shrine. At the far left is a seated statuette of Roma, at the far right a seated statuette of Asklepios.

Several pieces of evidence help to date the construction of the *domus*. A coin of the mid-3rd century A.D. was found in a well that was closed when the *domus* was built, and the foundations of the long concrete pool cut into a large pit containing pottery of the late 3rd or early 4th century A.D. Coins in the destruction debris suggest that the house burned down before the end of the 4th century A.D.

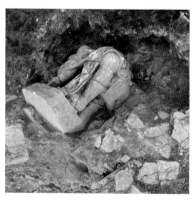

Figure 161. The statuette of Roma during excavation in 1999

PANAYIA BATH A Late Roman bath complex north of the *domus* consists of four rooms (Fig. 162): an entrance hall (E), an *apodyterium* that also served as a *frigidarium* (F),

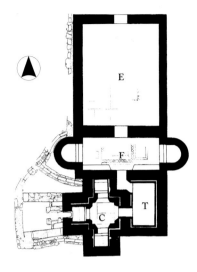

a *tepidarium* (T), and a *caldarium* (C). The *frigidarium* contained two cold tubs, while the cruciform *caldarium* had two warm tubs supplied with water through lead pipes. The water was fed from a tank to the west, heated by a *testudo* (a bronze device for maintaining the heat of the water). The *tepidarium* and *caldarium* both had hypocaust floors supported by andesite *pilae* (Fig. 163). The bath dates to the mid-6th century A.D.

Figure 162. Restored plan of the Panayia Bath

OTTOMAN-PERIOD CEMETERY North of the bath was a large 17th-century graveyard (Fig. 164). A majority of the burials were Christian. These were oriented roughly east–west, with the head to the west, facing slightly north of east, and the hands placed over the abdomen. There were also a few Muslim burials at the south edge of

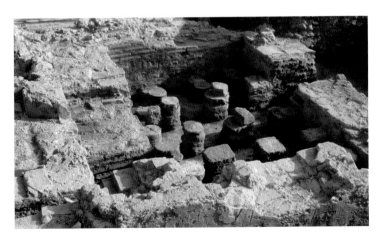

Figure 163. The hypocaust floor beneath the tepidarium *of the Panayia Bath, from the south*

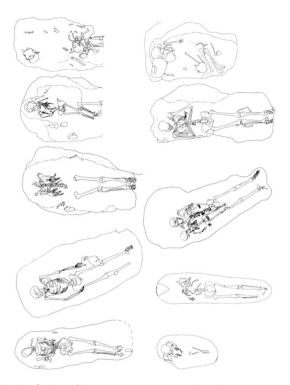

Figure 164. A selection of Ottoman graves excavated at the Panayia Field, including both Christian and Muslim burials

the cemetery. These were oriented northeast–southwest, with the head to the west but turned to the right to face southeast toward Mecca, and with the hands placed by the side of body.

Several individuals buried in the cemetery had met a violent end. One Christian grave contained the remains, in poor condition, of a male in his early 20s who was buried face down. A large iron hook found curving under the left clavicle was partially responsible for his death. It appears that he was spiked and suspended until he was dead and *rigor mortis* set in. He was then buried in a position that would prevent him from witnessing the Second Coming.

REMAINS OF THE EARLY MODERN PERIOD The latest remains in the Panayia Field are the foundations of houses and rubbish pits of the early-19th-century village. A pit dated by coins to after 1821

contained imported ceramics and wine bottles, lead bullets, flints from a flintlock rifle, a comb for head-lice, and fragments of a military uniform. The military-issue buttons have English inscriptions, and one is decorated with an American eagle. The assemblage is suggestive of the debris from the billet of an American who had been part of the corps of Philhellenes mustered at Corinth by President Mavrokordatos in the spring of 1822.

General: G. D. R. Sanders et al., *Hesperia* 83 (2014), pp. 1–79. **Geometric**: C. A. Pfaff, *Hesperia* 76 (2007), pp. 443–537. **Panayia Domus**: L. M. Stirling, *Hesperia* 77 (2008), pp. 89–161. **Bath**: G. D. R. Sanders, *Hesperia* 68 (1999), pp. 441–480. **Ottoman cemetery**: A. H. Rohn, E. Barnes, and G. D. R. Sanders, *Hesperia* 78 (2009), pp. 501–615.

⑥③ KRANEION BASILICA

⚡ (Locked; 1.4 km, 18 min.) From the site exit, go south out of the village square for 75 m, then head east for 1.3 km. Much of the site can be seen from the fence on the south side of the road.

The Kraneion suburb of ancient Corinth lay to the east of the city near the line of the Greek city wall. Scholars have speculated that the name may have been a corruption of "Karneion," after Karneus, a son of Zeus and Europa, and that, like the Spartans, the Corinthians celebrated a festival known as the Karneia.

In this district of the city lived Diogenes the Cynic, who famously asked Alexander the Great during their encounter to move aside so that he would no longer block the philosopher's sun (Plut. *Alex.* 14.2). Centuries later, Pausanias (2.2.4) saw the tomb of Diogenes here. Nearby, he saw the grave of the famous courtesan Lais, surmounted by a statue of a lioness with a ram in her forepaws, as well as sanctuaries of Bellerophon and Aphrodite Melaenis. Ancient sources also refer to an important gymnasium at Kraneion. None of these places has been identified. Several small excavations in the area have revealed parts of the Late Roman city wall, several graves dating to the Classical period, and a Christian basilica and cemetery near the Kenchrean Gate in the Classical city wall.

The Kraneion Basilica resembles the Lechaion Basilica ⑥⑧ but on a much smaller scale (Figs. 165, 166). It lacks an atrium but does have a baptistery on its north side. It is a cemetery church with ample evidence of vaulted brick cist graves extending over a large area to the south and west. Within the church are a number of private burial

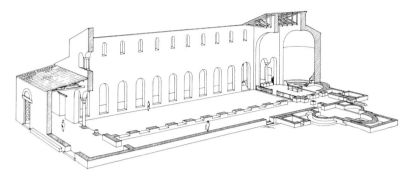

Figure 165. Axonometric drawing of the Kraneion Basilica

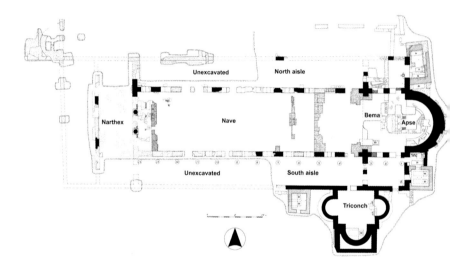

Figure 166. Plan of the Kraneion Basilica

monuments, accessed via the side aisles. A complete sigma table (a dining table Ⓜ) was found in the cemetery to the south. The screen from the church is on display in the museum courtyard Ⓜ. The date of this basilica is considered to be 6th century A.D., and the lamps, pitchers, and coins in the graves indicate that burial continued well into the 7th century A.D.

Corinth I.1 (1932), pp. 77–80; *Corinth* XVI (1957), pp. 7–9.

64 PALLAS BASILICA

⚡ (1.4 km, 20 min.) From the site exit, go south out of the village square for 75 m, then head east for 280 m to a crossroad at the hotel Rooms Marinos. Continue east for 100 m, then turn left. After 80 m, turn right onto a narrow road between two houses. This road winds eastward along the edge of the terrace. After 500 m, turn right (south) onto a dirt road just before the Smile of the Child charity. Continue south for 200 m. The basilica is in the field on the west side of the road.

The remains of a cement and rubble structure, thought by the Greek archaeologist Dimitrios Pallas to be an important basilica, were further investigated by the American School in 2000. Remote sensing survey and examination of the standing remains have shown that the building consists of a circular or octagonal structure, 12 m in diameter, attached to a rectangular structure 20 m square. To judge from the density of built cist graves to the north of the nearby city wall, this building might be a *martyrium*.

65 AMPHITHEATER

⚡ (1.4 km, 20 min.) From the Pallas Basilica, return to the road running along the edge of the terrace and continue eastward for 250 m. The Amphitheater is on the south side of the road after the Smile of the Child charity.

A large oval depression (79 m long × 52 m wide) marks the site of the arena of the Roman Amphitheater (Fig. 167). A broad gap on the south side probably marks the position of the *Porta Triumphalis,* the entrance to the arena. Traces of a massive concrete and masonry wall that originally supported the superstructure are visible in the olive grove on the southeast and southwest sides. These suggest exterior dimensions of ca. 100 × 70 m. Still visible are several steps cut into the

Figure 167. The Amphitheater, from the north

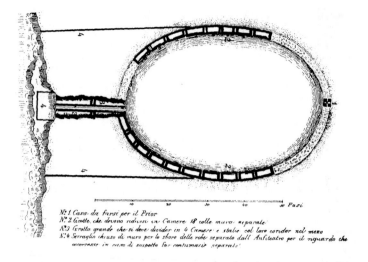

Figure 168. Plan of the Amphitheater in 1701 by Francesco Grimani

limestone cap above the marl deposits surrounding the depression.
These were either seats or cuttings for the placement of separately
carved seats that have since been robbed out. An early-19th-century
plan marks traces of seven staircases. The spacing suggests that these
divided the lower tier of seating on each side into six *kerkides* (wedge-
shaped seating areas). A *diazoma* (horizontal walkway) may have
divided the upper tier of seating from the lower. The lowest rows of
seats were cut into the marl beneath the limestone cap, and both these
and the superstructure above ground were presumably built of stone
quarried on site.

The superficial remains of the Amphitheater suggest that it was
built in the late 1st century B.C. and therefore belongs to the early years
of the colony. A scene from *The Golden Ass* (10.29), a 2nd-century A.D.
novel by the Roman author Apuleius, may have been set here. The
Amphitheater was later used by the Venetians as a *lazaretto* (place
of quarantine). The remains were mapped by Francesco Grimani in
1701 (Fig. 168), and by Abel Blouet, a surveyor with the French Morea
expedition, in the 1830s.

Corinth I.1 (1932), pp. 89–91.

NORTH OF THE CORINTH–PATRAS HIGHWAY

⑥⑥ NORTH CEMETERY

The North Cemetery is actually part of a much larger funerary area that extends along the plain below the lower terrace of the city. Excavations in 1915–1918 and 1928–1930 revealed 530 graves representing Corinthian burial practices over the course of 1,600 years (Fig. 169). The earliest graves were a cluster of 13 Middle Bronze Age burials, including one containing a gold diadem Ⓜ, perhaps originally covered by a tumulus. Next in date are 49 Geometric and 65 Protocorinthian graves. The remaining burials are Archaic, Classical, and Early Hellenistic, with a few of the Roman period. Later graves respected earlier burials, taking care not to disturb them. Grave goods from the graves are on display in the museum Ⓜ.

The favored burial practice was to place the body in a crouched position, lying on one side, in a built cist or, later, a limestone sarcophagus (Fig. 170). Pottery and other objects perhaps used in the burial ceremony were placed in and around the sarcophagus.

Corinth XIII (1964).

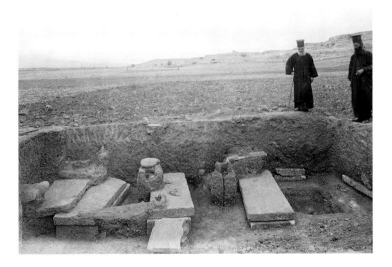

Figure 169. Graves in the North Cemetery in 1916

Figure 170. Several graves in the North Cemetery during excavation in 1930

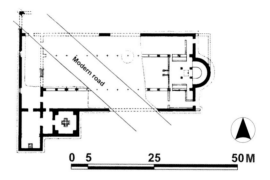

Figure 171. Plan of the Skoutela Basilica

❻❼ SKOUTELA BASILICA

The Early Christian basilica at Skoutela, on the plain north of the city, has three aisles and a baptistery on the south side (Fig. 171). It was constructed in the 6th century A.D., and seems not to have been used as a cemetery church.

❻❽ LECHAION BASILICA

The Early Christian basilica at the Corinthian harbor of Lechaion is built on a sand spit separating the inner basins of the harbor from the sea. A three-aisled basilica with two atria at the west end and a transept and single apse at the east end (Figs. 172, 173), it counts among the

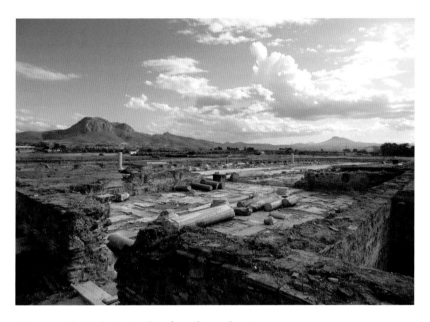

Figure 172. The Lechaion Basilica, from the northeast

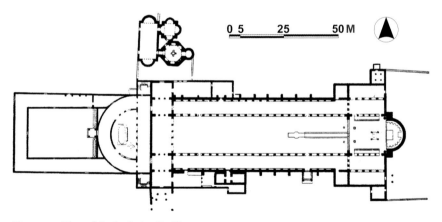

Figure 173. Plan of the Lechaion Basilica

largest such structures anywhere. The total length from outer atrium to apse is 180 m and is comparable to the size of the original basilica of Saint Peter in Rome. The size of the building made it a prominent landmark for those looking north from the city toward the Corinthian Gulf and for travelers arriving by land and sea.

Like all of the Early Christian basilicas at Corinth and many others in Greece, the nave of the Lechaion Basilica was divided from the aisles by the high stylobate of the colonnade and by screens between the columns. Clearly the intention was to separate the congregation in the aisles from activity in the nave. Galleries for the catechumens above the aisles were accessed by stairwells outside the basilica, immediately to the north and south of the inner atrium. The floors were paved with *opus sectile* panels and the lower walls were clad with marble revetment. The uniform order of columns, capitals, and screens were of Proconnesian marble from the Sea of Marmara and therefore appear to be an imperial donation, as indeed the whole church might have been. The ornate baptistery on the north side of the building is an independent construction consisting of three rooms: a rectangular lobby with apses at either end, an apodyterion with four exedras, and an octagonal room that served as the baptistery proper. Its plan is similar to that of contemporary bathhouses.

The basilica is thought to have been dedicated to Leonides, a 3rd-century bishop of Athens, who was hanged at Corinth. His body was then thrown into the sea at Lechaion. It was cast ashore, along with the bodies of seven Corinthian women who were drowned for mourning his death, and the local Christian community buried them on the beach and raised a church. A coin of Marcian (A.D. 450–457) found in a foundation trench indicates that the construction of the basilica was begun after the middle of the 5th century. A coin of Anastasius I (A.D. 491–518) gives a completion date after the early 6th century. If the basilica was standing in A.D. 521/2, it seems to have survived the earthquake of that year; the grave of a presbyter, Thomas, dating to ca. A.D. 600, was found under the collapsed walls of the building.

⑥⑨ KORAKOU

The settlement of Korakou (Fig. 174), a small mound on the coast west of modern Corinth, was continuously inhabited throughout the Bronze Age. It probably functioned as the harbor of the Bronze Age settlement located underneath the later city of ancient Corinth. Later graves, Archaic and Classical, have also been found in the area.

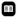

C. Blegen, *Korakou: A Prehistoric Settlement near Corinth* (1921).

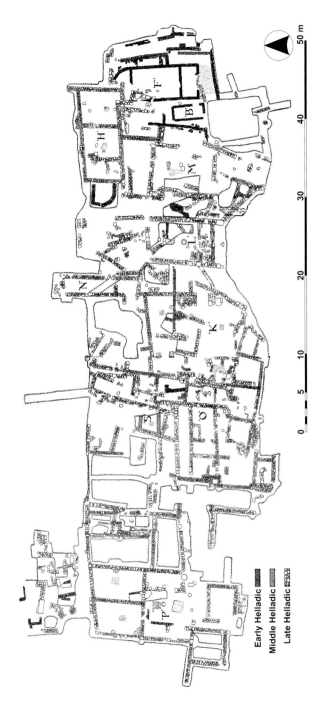

Figure 174. Plan of the Bronze Age settlement of Korakou

Early Helladic
Middle Helladic
Late Helladic

PREHISTORIC CORINTH AND THE CORINTHIA

Corinth's natural resources, good arable land, and copious fresh-water springs attracted early farmers to the site from the middle of the 7th millennium B.C. Artifacts excavated in the deposits discussed below (Fig. 175) are on display in the Prehistoric room in the museum ⓂⓇ. Early and Middle Neolithic deposits have been found at the main site, especially on Temple Hill ❹, in the Lechaion Road Valley ㊱, and on the West Terrace ⑮. Habitation continued in the same areas and extended to the vicinity of Temple E ❶ during the Late Neolithic period. Architectural remains of the period form a neighborhood west of the temples on the West Terrace ⑮. A house, a street, and an open-air work yard with numerous postholes for wooden frames suggest an area used for industrial processes, such as tanning.

The Early Helladic period is known from habitation deposits on Temple Hill, in the Lechaion Road Valley, and in the area of the museum and Temple E, as well as from Early Helladic II shaft graves on Panayia Hill. An Early Helladic II well at Cheliotomy-los ㊄ contained 20 to 30 human skeletons along with pottery, terracotta anchors, spindle whorls, a sealing (a small piece of

Figure 175. Neolithic and Early Helladic pottery and figurines mainly from the Forum and surrounding areas in Corinth

clay with an impression acting as the signature of the official in possession of the seal), and obsidian and bone tools. Remains of an Early Helladic II settlement were found in the area of the Gymnasium ㊗, while Early Helladic III pottery was among the finds from the Tile Works ㊱.

Although there is abundant evidence for extended habitation in the Neolithic and Early Helladic periods, the same is not true for the Middle and Late Helladic. The Romans probably eliminated most of the relevant strata when digging the deep foundations of the Roman colony. The dearth of material culture has led some to assert that Corinth did not exist during the Late Bronze Age. However, these claims are thrown into doubt by a number of facts. Members of an elite class were buried in a grave circle in the North Cemetery ㊏ on the plain to the north of the city at the end of the Middle Helladic period. That the hierarchical power structure continued in Late Helladic times is suggested by the discovery of a tholos tomb excavated by the Greek Archaeological Service in the plain to the northwest of Cheliotomylos in 2007. An absence of tholos tombs can thus no longer be used as an argument to support the hypothesis of Corinth's insignificance and its dominance by Mycenae during the Late Bronze Age. A Late Mycenaean deposit from the Julian Basilica ㉔, containing a *krater* manufactured in the Argolid and decorated with chariots Ⓜ, indicates that the area of the Forum was inhabited during this period. Such vessels formed part of the drinking service used at banquets among the Mycenaean elite.

The end of the Mycenaean period and the transition to the Early Iron Age are represented by remains in the area of the Forum, in the Sanctuary of Demeter and Kore ㊾ on the northern slope of Acrocorinth, and on Acrocorinth ㊿ itself. A reevaluation of the cyclopean parts of the fortifications on Acrocorinth is necessary, even if very difficult given their inaccessibility. Their traditional date in the Archaic period was based on the assumption that Corinth did not exist in the Late Bronze Age. This is no longer the case.

Other settlements around Corinth show continuous habitation throughout the Bronze Age. On the coast to the north,

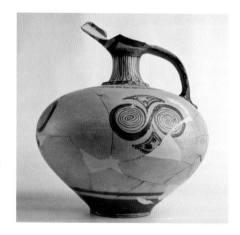

Figure 176. Late Helladic IIB (ca. 1500–1430 B.C.) beaked jug (CP-301) from Korakou, decorated in the Ephyraean Style with an isolated motif, here a group spiral, against a light background

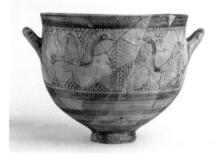

Figure 177. Late Helladic IIIC Middle (ca. 1150–1100 B.C.) deep bowl (CP-201) from Korakou, decorated in the Close Style with antithetic birds flanking a panel

Korakou ⑥⑨ was the harbor of the thriving settlement located on the inland terraces. The site was inhabited continuously from the Early Helladic to the Late Helladic period, and conducted a flourishing trade with sites to the east and west (Figs. 176, 177). The cemetery where the people of Korakou buried their dead has not yet been located, but Mycenaean burials have been excavated in New Corinth to the east and Ayios Gerasimos to the west. Zygouries, a royal perfume production site, and Athikia are two settlements on the road to Mycenae to the south. Dorati on the west controlled the route toward Tsoungiza and Nemea. Gonia and Yiriza to the east show habitation and burial from Neolithic through to Mycenaean times. The Corinthia was densely inhabited and prosperous in prehistoric times.

WALKS TO THE GREEK CITY WALLS

⚲ Short (4.2 km, 60+ min.) From the site exit, go south out of the village square for 75 m, then head east for 280 m to a crossroad at Rooms Marinos. Continue east for 100 m, then turn left. After 80 m, turn right onto a narrow road between two houses. This road follows the edge of the terrace, offering spectacular views of the Corinthian Gulf to the north and passing the Pallas Basilica **64** and Amphitheater **65**. After 1 km the paved road descends to the left. Take the track right, continuing along the edge of the terrace. Behind a house at 180 m follow the edge of the terrace southward, following traces of the city wall. Ca. 350 m south of the house is a gully marking the location of the Kenchrean Gate. Doubling back here for 150 m at the base of the slope brings one to the remains of Roman chamber tombs with sarcophagi still in situ. Continuing south along the terrace from the Kenchrean Gate for 450 m brings one to a junction of two paved roads. The hiker can return to the center of the village (1.6 km) along the north road past the Kraneion Basilica church **63**.

⚲ Longer (4.8 km, 90 min.) As above, but at the junction continue south, winding along the edge of the terrace. Well-preserved sections of the wall, built with ashlar blocks, can be easily traced. This section includes at least three round towers. After 800 m there is a paved road. Here the hiker can return to the center of the village (1.4 km) by following the road 1 km to the crossroad at Rooms Marinos and turning left.

⚲ Long (7 km, 2+ hr.) As above, but at the road continue southwest for 350 m to the top of a hill covered with olive trees. From here follow the crest of the hills for 1.2 km toward Acrocorinth. At this point one can follow a track at the base of the cliff for 500 m north to the northeast side of Acrocorinth and descend through the terraced fields for 1 km to the fountain of Hadji Mustafa **48** and 800 m farther to the village center.

CITY WALLS

70 GREEK CITY WALLS

The Classical walls, ca. 10 km in length, encompassed the ancient city and incorporated the acropolis, Acrocorinth. Long walls extended to the north protecting the city's connection with the harbor of Lechaion, as well as controlling passage across the plain from east to west. The walls were built of large ashlar masonry (or sometimes polygonal masonry in the older sections) with towers set at intervals.

From the east side of the acropolis, the wall followed the summits of three low hills descending toward the Xerias River valley. It then traced the line of the river terrace northward to a point east of the Amphitheater **65**. Here it turned west at least for a short distance

before descending to the lower terrace. It followed the edge of this terrace westward for ca. 2.7 km.

From the west side of the acropolis, the wall descends a rocky ridge northward past the Potters' Quarter **52** to the lower terrace. At the Potters' Quarter, the oldest portions of the city walls date from the Late Geometric period (Fig. 178).

Traces of the long walls connecting the city to the harbor at Lechaion have been followed and, in places, excavated. The long walls were exceptionally thick (ca. 3 m), constructed of two faces of ashlar blocks with a packed rubble core. The eastern line extended from the northeast corner of the city circuit for 1.8 km to a point west of the prehistoric site of Korakou **69**. The western line ran from the area of the Baths of Aphrodite **59** for 2.4 km to a point west of the Lechaion Basilica **68**.

71 LATE ROMAN CITY WALL

In 146 B.C. the Roman general Mummius reduced the Classical walls of Corinth to make them unusable for defensive purposes. No other wall was considered necessary until the Late Roman period, when a shorter circuit was constructed within the Classical circuit (Fig. 179). Timothy Gregory identified traces of massive masonry, including the so-called Epistyle Wall in the Gymnasium Area **56**, as belonging to this Late Roman wall. His reconstruction proposed a circuit of 5.3 km (approximately a square with sides of 1.5 × 1.3 km) with the Roman Forum at its center. He considered it to date to the early 5th century A.D. Another hypothesis, based on a recent resistivity survey, is that the wall enclosed an area about one quarter of this size and left the Roman Forum outside to the west. This hypothesis suggests a date in the mid-6th century for the wall and explains how the Forum could have been used for burials in the later 6th century when the law prohibited burial within the walls.

Corinth III.2 (1936); T. E. Gregory, Hesperia 48 (1979), pp. 264–280.

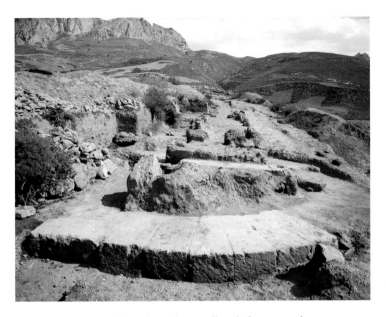

Figure 178. A section of the Classical city wall, including a round tower, near the Potters' Quarter in 1931

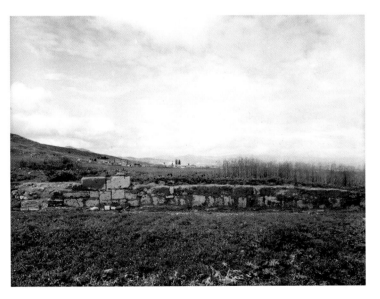

Figure 179. A section of the Late Roman city wall in the district of Kraneion in 1931

Plans

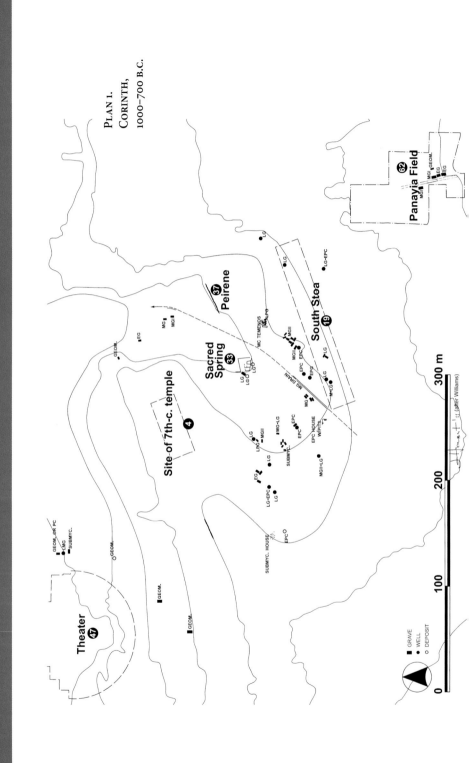

PLAN 1.
CORINTH,
1000–700 B.C.

PLAN 2.
CORINTH,
600–575 B.C.

0 10 50 100 m

after C. K. Williams II 1973

Trader's Complex **45**

Cyclopean Fountain **38**

Peirene **37**

Underground Shrine **40**

Sacred Spring **33**

House

Houses **31**

Archaic road **7**

Site of 7th-c. temple **4**

80

75

70

85

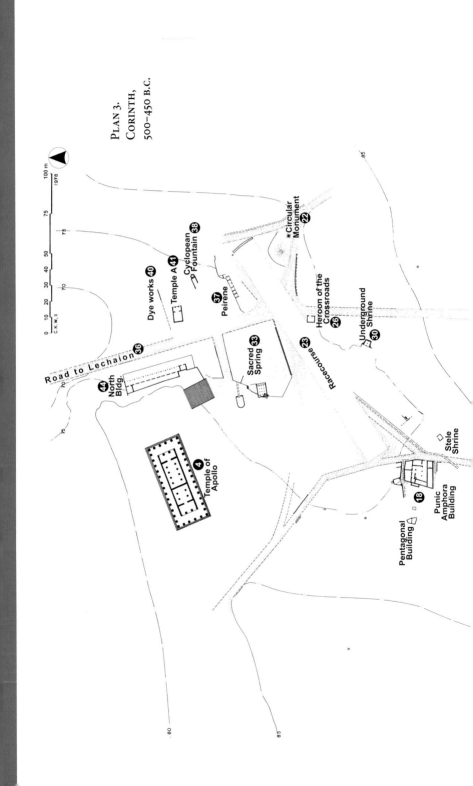

PLAN 3.
CORINTH,
500–450 B.C.

Road to Lechaion **36**

44 North Bldg.

4 Temple of Apollo

Dye works **40**

41 Temple A

Cyclopean **38**
Fountain

37 Peirene

33 Sacred Spring

Racecourse **23**

22 Circular Monument

Heroon of the Crossroads **26**

Underground Shrine **30**

Pentagonal Building

18 Punic Amphora Building

Stele Shrine

0 10 20 30 40 50 75 100 m
C.K.W. II 1978

75

70

75

70

75

80

85

80

85

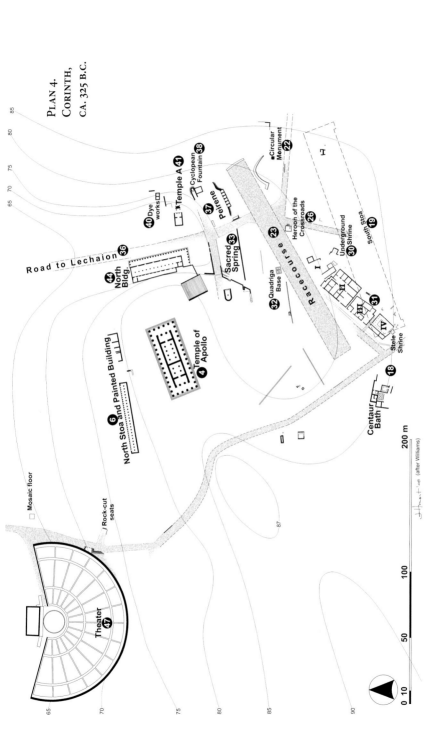

PLAN 4.
CORINTH,
CA. 325 B.C.

Theater 47

Mosaic floor
Rock-cut seats

North Stoa and Painted Building 6

Temple of Apollo 4

Road to Lechaion 36

North Bldg. 44

Dye works 40
Temple A 41
Cyclopean Fountain 38
Peirene 37
Sacred Spring 33

Quadriga Base 32
Stadium 23

Circular Monument 22

Heroon of the Crossroads 26
Underground Shrine 30
South Stoa 19

Stele Shrine 18
Centaur Bath

Racecourse

0 10 50 100 200 m

(after Williams)

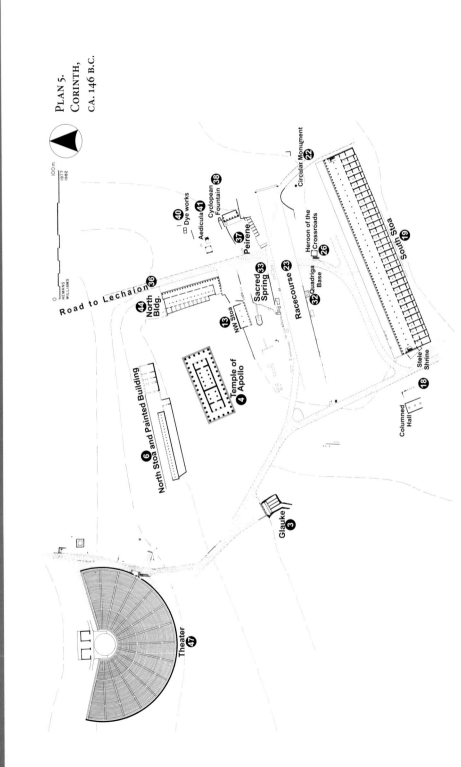

PLAN 5.
CORINTH,
CA. 146 B.C.

100 m
1977
1982

HEMANS
WILLIAMS

Road to Lechaion

Theater 47

Glauke 3

North Stoa and Painted Building 6

Temple of Apollo 4

NW Stoa 13

North Bldg. 44

36

Sacred Spring 33

Racecourse 23

Quadriga Base 32

Heroon of the Crossroads 26

Circular Monument 22

Columned Hall

Stele Shrine 18

South Stoa 19

Dye works 40

Aedicula 41

Cyclopean Fountain 38

Peirene 37

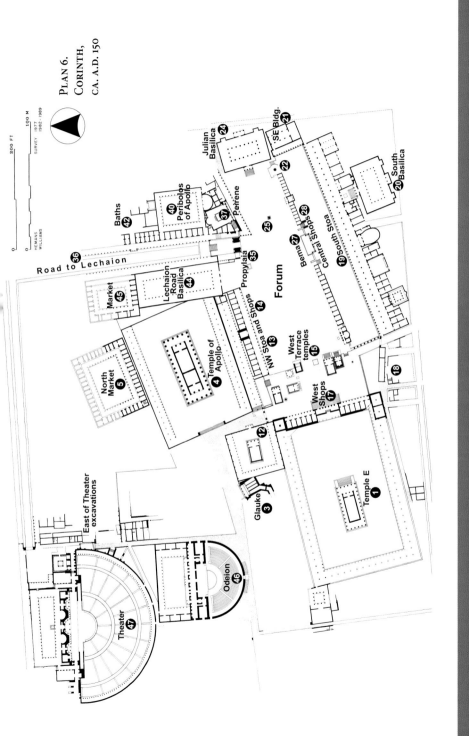

PLAN 6.
CORINTH,
CA. A.D. 150

200 FT
100 M

0
0

HERMANS 1977
WILLIAMS 1982-1989
SURVEY 1982-1989

Road to Lechaion

Baths 42
Peribolos of Apollo 40
Peirene 31
Julian Basilica 24
SE Bldg. 21
22
25
Market 45
Lechaion-Road Basilica 44
Propylaia 35
33
Forum
Bema 27 28
Central Shops
South Stoa 19
South Basilica 20
36
North Market 5
Temple of Apollo 4
NW Stoa and Shops 13 14
West Terrace temples 15
West Shops 17
18
Glauke 3
12
Temple E 1
East of Theater excavations
Theater 47
Odeion 46

PLAN 7.
CORINTH,
MEDIEVAL PERIOD

Julian Basilica

SE Bldg

South Stoa

South Basilica

Circular
Monument ㉒

Christian
church ㉗

Tower
Complex ㉖

South
Bath ㉘

South Stoa

S. L. Douias

Glossary

GLOSSARY

abacus	The uppermost member of a capital, with a plain profile in the Doric order and a molded profile in the Ionic order (see p. 198).
abaton	A term used variously in antiquity for sacred places to which access was limited.
Acrocorinth	The acropolis of ancient Corinth, Greece, continuously occupied from antiquity to the early 19th century.
adyton	A restricted, inner room of a Greek or Roman temple.
aedicula	A small shrine.
aedile	An official who supervised the maintenance of temples, public works, games, the water supply, and public entertainments.
agora	A public space and an essential part of an ancient Greek city, serving as a marketplace and place of assembly for the citizens.
aisle	A passageway on either side of the nave that is separated from the nave by columns or piers.
akroterion	A decorative architectural ornament mounted at the apex or lower angle of the pediment (see p. 198).
amphora	A two-handled jar with a narrow neck that was used in ancient times to store or carry wine or oils and other commodities.
anta	The end of a wall terminating in a pilaster.
apodyterium	The undressing room in a bath.
apse	A semicircular or polygonal recess in a wall or termination of a building, often vaulted.
Archaic period	Ca. 700–480 B.C., a period of significant advancements in political theory, marked by the rise of democracy, philosophy, theater, poetry, as well as the revitalization of the written language.

architrave	The lowest part of the entablature, resting on the capitals of the columns (see p. 198). Also known as the epistyle.
basilica	A Roman public building erected for commercial and legal business, generally with a central nave flanked by side aisles, and an apse at one or both ends. The building type was later adopted for Christian churches.
bema	A speaker's platform.
Bey	A title given to a provincial governor and other officials in the Ottoman Empire.
Bronze Age	A period that corresponds roughly to the 3rd and 2nd millennia B.C. and takes its name from the use of bronze to make tools.
Byzantine period	The term used since the 19th century to describe the Greek-speaking Roman Empire of the Middle Ages, centered on its capital of Constantinople. The Byzantine Empire is also known as the Eastern Roman Empire.
caldarium	A room in a bath with hot bath tubs.
capital	The crowning member of a column (see p. 198).
cella	The inner chamber of a temple, also called a *naos*.
Classical period	Ca. 480–323 B.C.
Corinthia	The territory of the ancient city of Corinth and not the modern county of the Corinthia.
Corinthian Gulf	A deep inlet of the Ionian Sea separating the Peloponnese from western mainland Greece and bounded in the east by the Isthmus of Corinth.
Corinthian order	An order of architecture characterized by a base supporting a slender, fluted column, with an ornate capital decorated with acanthus leaves and volutes (see p. 198).
cornice	The upper part of the entablature (see p. 198).
cryptoporticus	An underground vaulted corridor or passageway supporting structures above.

distyle in antis	Having two columns between the antae.
Doric	An order of architecture in which the columns stand directly on the stylobate without a base, topped by a capital including an echinus and abacus (see p. 198).
duovir or *duumvir*	One of a panel of two elected officials who administered justice, oversaw the assembly and finances, and convoked and presided over the senate. He held office for a year.
Early Helladic period	Ca. 3250–2100 B.C., the first subdivision of the Bronze Age.
echinus	The molding in a Doric capital that supports the abacus, with its profile ranging from a circular cushion to a cone (see p. 198).
entablature	The superstructure supported by the columns, and including the architrave, frieze, and cornice (see p. 198).
epistyle	A Greek term for the architrave (see p. 198).
exedra	A semicircular or rectangular recess, or a semicircular stone or marble bench.
frieze	The middle part of the entablature. In the Doric order, it may be divided into triglyphs and metopes, while in the Ionic or Corinthian order it may be divided into horizontal bands (*fasciae*) or decorated with reliefs (see p. 198).
frigidarium	A room in a bath with tubs for unheated water.
Geometric period	A phase of Greek art, characterized by geometric motifs in vase painting, which flourished near the end of the Dark Ages, ca. 900–700 B.C.
gymnasium	A training facility for competitors in public games, or a place for socializing and engaging in intellectual pursuits.
Helladic period	A modern term for a sequence of periods characterizing the culture of mainland Greece during the Bronze Age (3rd and 2nd millennia B.C.).

Hellenistic period	The period between the death of Alexander the Great in 323 B.C. and the annexation of Greece by Rome in 146 B.C.
himation	A heavy, woolen cloak.
hypocaust	A system of underfloor heating in which pillars support the floor and hot air from adjacent furnaces circulates around the pillars and heats the room above.
in antis	Latin for "between the antae," usually referring to columns that stand between the ends of projecting lateral walls.
in situ	Latin for "in position"; used to refer to archaeological objects or monuments that remain in their original positions.
Ionic	An order of architecture characterized by a base supporting a slender fluted column, with a capital decorated with scrolling volutes (see p. 198).
Isthmus	In the Corinthia, the narrow land-bridge which connects the Peloponnese with the mainland of Greece, near the city of Corinth. To the west of the Isthmus is the Gulf of Corinth, to the east the Saronic Gulf. Since 1893 the Corinth Canal has run through the 6.3 km Isthmus, making the Peloponnese an island.
krepidoma	The stepped platform of a Greek temple or other structure (see p. 198).
Late Helladic period	Ca. 1680–1050 B.C., the time when the Mycenaean civilization of Greece flourished.
Lechaion	One of the two ports of the city-state of Corinth. Kenchreai served the eastern trade routes and Lechaion, through the Corinthian Gulf, served the trade routes leading west to Magna Graecia and the rest of Europe.
marl	A calcium carbonate or lime-rich mud or mudstone which contains variable amounts of clays and aragonite.

martyrium	A church or other edifice built at a site, especially a tomb, associated with a Christian martyr or saint.
metope	A space between two triglyphs in a Doric frieze, which can be plain or with painted or sculptured decoration (see p. 198).
Middle Helladic period	Ca. 2100–1680 B.C., the second subdivision of the Bronze Age in mainland Greece.
naos	The Greek term for the inner chamber *(cella)* of a temple.
narthex	The porch or lobby of a Christian church.
nave	The central part of a Christian basilica, extending from the narthex to the high altar.
Neolithic period	Ca. 7000 B.C., the approximate time of the first farming societies, to ca. 2800 B.C., the beginning of the Bronze Age.
oolitic limestone	A sedimentary rock composed largely of the mineral calcite (calcium carbonate).
opus sectile	Paving or wall decoration composed of cut pieces of colored stones or marble.
orchestra	The performance space, generally circular in plan, of a theater or odeion.
Ottoman period	The period from the 15th century to A.D. 1821, when most of Greece was part of the Ottoman Turkish empire.
pediment	The triangular gable beneath the roof of a building (see p. 198).
peribolos	A sacred enclosure or *temenos*.
pilae	Stacks of tiles that support a hypocaust floor.
plateia	A village square.
pontifex	A member of the college of *pontifices*, the senior college of priests in Rome and in Roman colonies.
poros	A term used to refer generally to any soft limestone.

proconsul	The governor of a Roman province.
propylon	A monumental gateway.
prostyle	A temple with a portico of columns in front.
Protogeometric period	A chronological period (11th–10th century B.C.) associated with a pottery decorated with broad horizontal bands about the neck and belly and concentric circles applied with compass and multiple brush.
revetment	Thin slabs of stone used as an ornamental facing.
Roman period	In Greece, conventionally, the period following the Roman victory over the Corinthians in 146 B.C. until the establishment of Constantinople in A.D. 330.
sarcophagus	A funeral receptacle for a corpse, most commonly box-shaped and carved or cut from stone.
sima	The gutter of a building, provided with outlets for rainwater sometimes in the shape of lions' heads (see p. 198).
spina	The divider in the center of the racetrack of a Roman circus.
stele	An upright stone or wooden slab, generally inscribed or with sculpted decoration.
stoa	A long building, with its roof supported by one or more rows of columns parallel to the back wall.
stylobate	The top step of the krepidoma of a building, on which the columns were set (see p. 198).
tekke	The shrine of a Muslim saint.
temenos	A sacred precinct or sanctuary.
tepidarium	A warm room in a bath.
tetrastyle	A building with four columns across the facade.
triglyph	Vertical grooved members alternating with metopes in a Doric frieze (see p. 198).

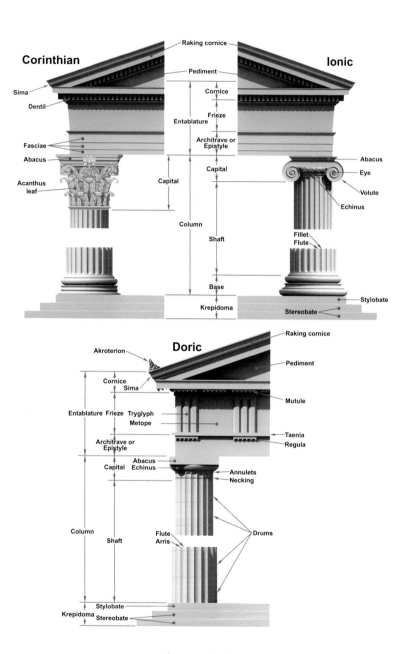

Architectural orders

List of
Publications

LIST OF PUBLICATIONS CONCERNING THE EXCAVATIONS AT CORINTH PUBLISHED BY THE AMERICAN SCHOOL OF CLASSICAL STUDIES AT ATHENS

CORINTH: RESULTS OF EXCAVATIONS CONDUCTED BY THE AMERICAN SCHOOL OF CLASSICAL STUDIES AT ATHENS

A series of scholarly monographs on the final results of the excavations.

I.1 H. N. Fowler and R. Stillwell, *Introduction, Topography, Architecture* (1932).

I.2 R. Stillwell, R. L. Scranton, and S. E. Freeman, *Architecture* (1941).

I.3 R. L. Scranton, *Monuments in the Lower Agora and North of the Archaic Temple* (1951).

I.4 O. Broneer, *The South Stoa and Its Roman Successors* (1954).

I.5 S. S. Weinberg, *The Southeast Building, the Twin Basilicas, the Mosaic House* (1960).

I.6 B. H. Hill, *The Springs: Peirene, Sacred Spring, Glauke* (1964).

II R. Stillwell, *The Theatre* (1952).

III.1 C. W. Blegen, R. Stillwell, O. Broneer, and A. R. Bellinger, *Acrocorinth: Excavations in 1926* (1930).

III.2 R. Carpenter and A. Bon, *The Defenses of Acrocorinth and the Lower Town* (1936).

IV.1 I. Thallon-Hill and L. S. King, *Decorated Architectural Terracottas* (1929).

IV.2 O. Broneer, *Terracotta Lamps* (1930).

V T. L. Shear, *The Roman Villa* (1930).

VI K. M. Edwards, *Coins, 1896–1929* (1933).

VII.1 S. S. Weinberg, *The Geometric and Orientalizing Pottery* (1943).

VII.2 D. A. Amyx and P. Lawrence, *Archaic Corinthian Pottery and the Anaploga Well* (1975).

VII.3 G. R. Edwards, *Corinthian Hellenistic Pottery* (1975).

VII.4 S. Herbert, *The Red-Figure Pottery* (1977).

VII.5 M. K. Risser, *Corinthian Conventionalizing Pottery* (2001).

VII.6 I. McPhee and E. G. Pemberton, *Late Classical Pottery from Ancient Corinth: Drain 1971-1 in the Forum Southwest* (2012).

VIII.1 B. D. Meritt, *Greek Inscriptions, 1896–1927* (1931).

VIII.2 A. B. West, *Latin Inscriptions, 1896–1926* (1931).

VIII.3 J. H. Kent, *The Inscriptions, 1926–1950* (1966).

IX F. P. Johnson, *Sculpture, 1896–1923* (1931).

IX.2 M. C. Sturgeon, *Sculpture: The Reliefs from the Theater* (1977).

IX.3 M. C. Sturgeon, *Sculpture: The Assemblage from the Theater* (2004).

X O. Broneer, *The Odeum* (1932).

XI C. H. Morgan II, *The Byzantine Pottery* (1942).

XII G. R. Davidson, *The Minor Objects* (1952).

XIII C. W. Blegen, H. Palmer, and R. S. Young, *The North Cemetery* (1964).

XIV C. Roebuck, *The Asklepieion and Lerna* (1951).

XV.1 A. N. Stillwell, *The Potters' Quarter* (1948).

XV.2 A. N. Stillwell, *The Potters' Quarter: The Terracottas* (1952).

XV.3 A. N. Stillwell and J. L. Benson, *The Potters' Quarter: The Pottery* (1984).

XVI R. L. Scranton, *Mediaeval Architecture in the Central Area of Corinth* (1957).

XVII J. C. Biers, *The Great Bath on the Lechaion Road* (1985).

XVIII.1 E. G. Pemberton, *The Sanctuary of Demeter and Kore: The Greek Pottery* (1989).

XVIII.2 K. W. Slane, *The Sanctuary of Demeter and Kore: The Roman Pottery and Lamps* (1990).

XVIII.3 N. Bookidis and R. S. Stroud, *The Sanctuary of Demeter and Kore: Topography and Architecture* (1997).

XVIII.4 G. S. Merker, *The Sanctuary of Demeter and Kore: Terracotta Figurines of the Classical, Hellenistic, and Roman Periods* (2000).

XVIII.5 N. Bookidis, *The Sanctuary of Demeter and Kore: The Terracotta Sculpture* (2010).

XVIII.6 R. S. Stroud, *The Sanctuary of Demeter and Kore: The Inscriptions* (2013).

XVIII.7 N. Bookidis and E. G. Pemberton, *The Sanctuary of Demeter and Kore: The Greek Lamps and Offering Trays* (2015).

XX C. K. Williams II and N. Bookidis, eds., *Corinth, the Centenary: 1896–1996* (2003).

XXI K. W. Slane, *Tombs, Burials, and Commemoration in Corinth's Northern Cemetery* (2017).

HESPERIA SUPPLEMENTS

A series of book-length studies in Greek archaeology, published as supplements to *Hesperia: The Journal of the American School of Classical Studies at Athens*. Volumes devoted to Corinthian material are:

28. D. A. Amyx and P. Lawrence, *Studies in Archaic Corinthian Vase Painting* (1996).

35. G. S. Merker, *The Greek Tile Works at Corinth: The Site and the Finds* (2006).

CORINTH NOTES

Brief guides presenting interesting discoveries from the excavations.

1. M. Lang, *Cure and Cult in Ancient Corinth* (1977).

2. N. Bookidis and R. S. Stroud, *Demeter and Persephone in Ancient Corinth* (1987).

ANCIENT ART AND ARCHITECTURE IN CONTEXT

A series funded by the Getty Foundation.

2. B. A. Robinson, *Histories of Peirene: A Corinthian Fountain in Three Millennia* (2011).

Index

INDEX

Numbers in **Bold** = *main entry or description*

CAPTIONS AND CREDITS

pp. 14–15: Korinth mit dem Apollontempel, by Ludwig Lange (1834–1835).

pp. 22–23: The spring facade and round pool of Peirene in 1899.

pp. 28–29: The Temple of Apollo at sunrise.

pp. 126–127: The village of Ancient Corinth below the slopes of Acrocorinth.

Fig. 1: O. Dapper, Naukeurige beschryving van Morea, eertijts Peloponnesus (Amsterdam 1688), p. 34.

Fig. 3: O. M. von Stackelberg, Trachten und Gebräuche der Neugriechen (Berlin 1831), pl. V.

Fig. 4: W. Brockedon, Finden's Illustrations of the Life and Works of Lord Byron, vol. III (London 1834).

Fig. 27: O. M. von Stackelberg, La Grèce: Vues pittoresques et topographiques (Paris, 1834), pl. 40.

Fig. 37: Biblioteca Medicea Laurenziana. Courtesy Web Gallery of Art.

Fig. 78: Museo de El Greco. Courtesy Web Gallery of Art.

Fig. 167: Courtesy J. Bravo.

Fig. 168: S. P. Lambros, "Ueber das korinthische Amphitheater," AthMitt 2 (1877), pp. 282–288, pl. 19.

Fig. 172: Courtesy R. Valente.

Unless otherwise noted, all illustrations are courtesy of the Corinth Excavations.